now now now now now now now now now now now now now now now now now now now now now now now now now now now now now now now now now now

# typography
# NOW
## NOW

the next wave

D0124782

edited by
**rick poynor
& edward booth-clibborn**

selected by
**rick poynor
& why not associates**

book design
**why not associates**

cover photograph by why not & rocco redondo.
end paper photography by pirco wolfframm & alistair lever.
computer-generated wave on cover by simon scott.
set in monotype grotesque by alphabet set.
printed and bound in japan by dai nippon printing

distributed in the united states of america by north light books, an imprint of l&w publications, inc. world rights: booth-clibborn editions, 12 percy street, london w1p 9fb.

distribution except usa & uk:
hearst books international

the typefaces beowolf,
brokenscript, lunatix,
oakland, matrix,
modular, scratch, totally
gothic, triplex and vortex
were kindly supplied by
fontworks, a division of
fontshop international.

first published in 1991 by
booth-clibborn editions.
reprinted (three times) 1992.
reprinted 1993.
first paperback edition 1994.
copyright © 1991
booth-clibborn editions.
introduction copyright
© 1991 rick poynor.

introduction

typography

type

"Type is going to be as abstract as sand on a beach. In that sense type doesn't exist anymore."

MAX KISMAN

# type

## and
## deconstruction

## in the

## digital era

by rick poynor

In the age of the desktop computer, font design software and page make-up programs, type has acquired a fluidity of physical outline, an ease of manipulation and, potentially, a lack of conceptual boundaries unimaginable only a few years ago. Everyone agrees that the new **digital tools** remove typography from the exclusive domain of the specialist – whether type designer, typefoundry or typesetting company – and place it (not always firmly) in the hands of the ordinary graphic designer. The results of this freedom, however, are the subject of intense and continuing debate. Traditionalists argue that the accessibility of the technology will accelerate the decline in typographic standards that started when the first clumsy photocomposition systems began to replace lead type. Evangelists enthuse about a soon to be realised **digital paradise** in which everyone will compose letters in personally configured typefaces as idiosyncratic as their own handwriting.

¶*Typography now: the next wave* is an interim report on these changes, filed while they are still under way. It collects new work – from America, Britain, Germany, France and The Netherlands – which is redefining our approach to typography. Some of these designs are entirely dependent on the new technology; in production terms it would be simply too time-consuming, costly or awkward to generate them in any other way. Some of them anticipate the aesthetic concerns of the new **digital typography,** or reflect the freedoms that the technology makes possible, while still being produced at the drawing board, or by letterpress. Some will stand the test of time; others will prove to have been representative of their period, but of no greater significance. All of them demonstrate their designers' reluctance to accept that the conventions of typography are inscribed inviolably on tablets of stone.

¶Among these articles of faith, legibility is perhaps the first and most emotive. If there is one characteristic that links the many visual strategies of the new typographers, it is their combined assault on this most sacred of cows. Swiss-school modernism composed orderly, linear, well-tempered messages using supposedly objective, and certainly inexpressive, sanserif letterforms. The new typographers, reacting against this bloodless neutrality, justify their experiments by arguing that

**no typeface is inherently legible;**

rather, in the words of type designer ZUZANA LICKO of Emigre Graphics,

"it is the reader's familiarity with faces that accounts for their legibility".[1]

We might find it impossible to read black letter with ease today, but in pre-war Germany it was the dominant letterform. Baskerville, rejected in 1757 as ugly and unreadable, is now regarded as one of the most serviceable typefaces for long text setting.

¶Type design in the

digital era

is quirky, personal and unreservedly subjective.

The **authoritarian voices of modernist typography,** which seem to permit only a single authorised reading, are rejected as too corporate, inflexible and limiting, as though typographic diversity itself might somehow re-enfranchise its readers.

"I think there are a lot of voices that have not been heard typographically,"

says Californian type designer JEFFERY KEEDY

"Whenever I start a new job and try to pick a typeface, none of the typefaces give me the voice that I need. They just don't relate to my experiences in my life. They're about somebody else's experiences, which don't belong to me."[2]

¶Another American type designer, BARRY DECK, speaks of trading in the

"myth of the transparency of typographical form for a more realistic attitude toward form, acknowledging that form carries meaning",[3] - - - - - - - - - - - - - - - - -

**1.** "Do you read me?", *Emigre*, No.15, 1990, p.12.
**2.** *Emigre*, No.15, pp.16-17.
**3.** Designer's statement, August 1991.
**4.** *Emigre*, No.15, p.17.

The aim is to promote multiple rather than fixed readings, to provoke the reader into becoming an active participant in the construction of the message. Later modernist typography sought to reduce complexity and to clarify content, but the new typographers relish

**ambiguity,**

preferring the provisional utterance, alternative take and delayed punchline to the finely honed phrase.

"If someone interprets my work in a way that is totally new to me, I say fine," says Keedy. "That way your work has a life of its own. You create a situation for people to do with it what they will, and you don't create an enclosed or encapsulated moment."[4]

Citizen Light
**Citizen Bold**

Zuzana Licko. Citizen typeface. 1990

¶For Keedy, Deck, Emigre Graphics and colleagues such as NEVILLE BRODY and JONATHAN BARNBROOK in Britain, and MAX KISMAN in The Netherlands, designing typefaces for personal use is a way of ensuring that graphic design projects carry their own specific

**identity**

and tone of voice. The pre-digital typefaces that Brody drew for *The Face* emphasised the new perspectives on contemporary culture embodied in the magazine's editorial. They also functioned as a medium through which Brody could develop a socio-cultural

**commentary**

of his own. Typeface Two, designed in 1984, was deliberately authoritarian in mood, in order, Brody said, to draw a parallel between the social climate of the 1930s and 1980s. The typeface's geometric rigidity was persistently undermined by the light-hearted manner in which it was applied. Other designers take an even more idiosyncratic approach. For Barry Deck, the starting point for a type design is not traditional notions of legibility or elegance, but a highly subjective and seemingly arbitrary

**narrative**

founded on the supposed correlation between sexuality and letterforms.

Neville Brody
12" single cover
1984

Neville Brody
Typeface Two
1984

Neville Brody
Application of Typeface Two
*The Face* magazine, 1984

**5.** Designer's statement.

"With this in mind, I began imposing narratives of sexual angst, deviation and perversion on the design of my type. Because the F is a particularly important letter in the language of sexuality, it came to be a major point of activation in all of the alphabets." [5]

¶In this polymorphous——————digital realm, typefaces can cross-fertilise each other or merge to form strange new——————hybrids. Kisman's Fudoni Bold Remix mixes Futura and Bodini; Barnbrook's Prototype is collaged together from the parts of ten other typefaces, among them Bembo, Perpetua and Gill; and Deck's Canicopulus Script is Gill Sans Serif with the satirical addition of puppy-dog tails. Other typeface designs are more polemical than practical in their acknowledgement of the contingency, impermanence and potential for chaos which is a basic condition of the digital medium.

ERIK VAN BLOKLAND and JUST VAN ROSSUM's Beowolf is a family of unpredictable random fonts programmed for three levels of randomness whose broken, antique outlines shift and reform every time a letter is produced so that no character is ever the same twice. Van Blokland and van Rossum, mavericks with a semi-serious message about the shortcomings of computerised perfection, speculate on the possibility of developing fonts that will cause characters to drop out at random, or to print upside down, and typefaces that will slowly decay until they eventually become illegible in a digital parody of hot-metal type. Jonathan Barnbrook goes a step further by extending this nihilistic randomising principle to the text itself. His typeface Burroughs (named after the novelist with a penchant for textual "cut-ups") replaces whatever is typeset with a stream of gibberish generated at random by the software.

¶Hand in hand with this investigation of the new aesthetic possibilities of the computer comes **a revaluation of the artless and the ugly, the hand-made and the ready-made.** For designers who are dissatisfied with the glib solutions and formulaic perfection of professional graphics, naive

**vernacular**

approaches to type (and imagery) appear to offer a rich seam of authenticity, allusion, expression and meaning. HARD WERKEN, THE THUNDER JOCKEYS, JOHN WEBER and BARRY DECK value letterforms – hand-drawn and mechanical – for their impurities and flaws.

"I am really interested in type that isn't perfect,"

says Deck.

"Type that reflects more truly the imperfect language of an imperfect world inhabited by imperfect beings."[6] Deck's typeface Template Gothic, based on an old sign he found in a laundromat, is an attempt to capture the spirit of crude lettering templates by using truncated strokes, erratic, tapered letterforms, and letters that look like they are the degraded product of photomechanical reproduction.

EDWARD FELLA, a former commercial artist, creates posters that break every known rule of typographic decorum and designer good taste. In Fella's agitated hands, type is spun, tilted, stretched, sliced, fractured, drawn as if with a broken nib, and set loose among fields of ink-blotter doodles and networks of rules. He is perhaps the most extreme example in these pages of the typographer as artist – an innovator who assumes and achieves the same level of creative freedom as the painters and sculptors whose exhibitions he promotes in catalogues and posters.

Hard Werken
Hand-drawn type
1982

¶Fella, significantly, is a graduate of the Cranbrook Academy of Art,
the source of many of the most interesting developments in new typography.
Few Cranbrook exercises, however, are entirely typographic; the most typical
concentrate on the relationship of

## image and text.

Cranbrook has been at the forefront in exploring the dense, complex

## layering of elements

that is one of the most salient (and frequently criticised) characteristics of the
new typographic design. Unlike the earlier work of the New Wave designers, this
is not simply a formal exercise in collage-making; the method arises directly from

## an engagement with content.

The Cranbrook theorists' aim, derived from French philosophy and literary
theory, is to

## deconstruct,

or break apart and expose, the

## manipulative visual language

and different levels of meaning embodied in a design, in the same way that
a literary critic might deconstruct and decode the verbal language of a novel.

**6.** *Emigre*, No.15, p.21.

**7.** "A brave new world: understanding deconstruction", *Print*, XLIV:VI, November/ December 1990, p.83. See also: Katherine McCoy and David Frej, "Typography as discourse", *ID*, Vol. 35 No. 2, 1988, p.34-37.

"When the deconstructionist approach is applied to design,"
write the American critics Chuck Byrne and Martha Witte,
"each layer, through the use of language and image, is an intentional performer in a deliberately playful game wherein the viewer can discover and experience the hidden complexities of language."[7]
The work that results (seen in this book in examples by KATHERINE McCOY,
ALLEN HORI and P. SCOTT MAKELA) is a direct challenge to its audience, which must
learn to "read" these layered, allusive, open-ended image/type constructions
with the same close attention that it would bring to a difficult piece of text.

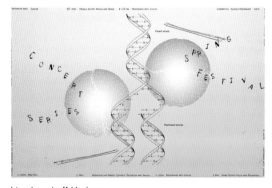

Lisa Langhoff Vorhees,
Cranbrook Academy of Art
Concert poster
1990

¶Although the idea of deconstruction is gaining ground among designers in the US, and enjoys some currency in Europe where it originated, few typographers, at this point, would feel sufficiently confident of the theoretical basis of the term to describe themselves as deconstructionists. Yet the visual strategies of deconstruction, driven by the

two faces for the 90's— john wesley harding (singer-songwriter) , beach culture magazine.

the jesus and mary chain on the Santa Monica pier

mary;'s danish on bottled water art, places st Yle

plus the usual mix of art, places st Yle

and ATTITUDE. our special

on the Road in Jamaica, ZANZIBAR, Hawaii and Kentucky

the ULTIMATE :: A sport

rd st TIMATE :: A sport that lives up to its name.
on the Road in Jamaica, ZANZIBAR, Hawaii and Kentucky.
the jesus and mary chain on the Santa Monica pier

hook stores.

RESHOPS and the beach

David Carson
*Beach Culture* magazine
1990

## layering capabilities of the computer, are already widely dispersed.

The Californian surfing magazine *Beach Culture* rapidly became both *cause célèbre* and designer's *bête noire* for the deconstructive

### frenzy

with which its art director, DAVID CARSON dismantled the typography of contents pages, headlines and text. In London, WHY NOT ASSOCIATES bring a similar typographic abandon to their catalogue dividers and covers for the clothing company Next. In each case the visual

### delirium

is formally stunning, but its relevance to the content is not always clear. Both in their different ways are examples of what Andy Altmann of Why Not Associates calls

### type as entertainment.

The designs function decoratively as a means of engaging, amusing, persuading and no doubt sometimes infuriating the reader, rather than as vehicles for extending meaning or exploring the text.

¶Such issues are unavoidable when it comes to the design of long pieces of prose. The questions of legibility and personal expression that preoccupy the new typographers become far more acute when the aim is to hold the reader's attention over the course of many pages. Are the new fonts suitable for any purpose other than exotic display? Or is it time, perhaps, to re-examine the rigidly drawn distinction between typefaces for text and titles? Emigre Graphics, which is able to road-test its typefaces in its own magazine, has demonstrated the surprising readability of even the most bizarre and apparently

### unpromising fonts,

given a little familiarity with their quirks. *Emigre*'s designer RUDY VANDERLANS mixes seemingly

### incompatible faces,

varies point size and line depth, centres text over extra-wide measures, changes column width within articles, and runs two or more text-strands in parallel – most of the time

### without

undue

### loss of legibility.

Phil Baines
Postcard
1986

**PHIL : J THING NG TO EARS C**
anuary 1986. LO s happening and w lift a seven foot H ompletion. 5: (At
**OKING ONE** ork being done, a **AIRY CIRCLE** last). A red, moun
**WAY**, pounds st good spirit. 3: An made of Silver Bir tain **BIKE**, lost fo
erling; design as h dy Goldsworthy on ch. 25th January.' r a moment, **IN S**
igh street fashion Hampstead Heath 4: A Map of **THE NOW** at 1100 fe
as design. **LOO** , 'Very cold. Help! **CITY** of London n et, and rememberi
**KING ANOT** o develop my idea( ng the running I c
**HER**, 1: Re the a bove, remembered I)s . . . . **DESIGNERS PLAYI** an no longer do: '1
card from May 19
84, ( **EXTRAC** **POSITIVE ROLE IN SOCI**
**T RIGHT**) at od ds but still an aspi . . **I LIKE** that; it's a t is the caged taki
ration. 2: Another good st**ART**. ng wing but it is n
term. Feels like an ot space encompas
other college with sed'. (K. Gibran).

¶But *Emigre* remains the exception. Most designers experimenting with radical approaches to page structure and typographic hierarchy work with a far more restricted and conventional selection of typefaces. The British typographer and letterpress exponent P H I L   B A I N E S has turned to

## medieval manuscripts,

Marshall McLuhan's *The Gutenberg galaxy,* concrete poetry and artists' books for

## alternative models
## of textual organisation.

Baines's autobiographical postcards and his undergraduate thesis, "The Bauhaus mistook legibility for communication", combine editorial rigour and sensitivity to language with a playful sense of typographic possibility.

"Legibility, presents information as facts rather than as experience,"[8] says Baines. There is nothing wrong with logic and linearity, he argues, but these qualities satisfy only the rational side of the brain. For Baines and his colleagues, it is equally important that

typography should address our capacity for intuitive insight and simultaneous perception, and stimulate our senses as well as engaging our intellect.

¶Baines's most experimental work is still to be found in his personal projects, but in the last two years there have been a number of striking attempts to redefine the syntax of the conventional book. T I B O R   K A L M A N 's catalogue for an exhibition about chaos theory and the arts subjects the essays to extremes of typographic distortion in an attempt to embody the exhibition's theme. In one essay, the word-spacing increases progressively until the

## text disintegrates into particles;

in another, bold and under-sized characters are sprinkled randomly throughout the text. Avital Ronell's *The telephone book*, a discourse on the history, philosophy and psychoanalytical implications of the telephone, subverts the traditional elegance of a university press publication with a catalogue of

## typographic mishaps

and metaphorical wrong numbers. Lines of type ripple with size changes, sections of text are crossed out or tilted at angles, whole pages are obscured by over-setting or

## photographic erosion,

fragments of setting float free of the grid, and arguments break off and are never resumed. It is as though the entire book – a collaboration between "switchboard operator" Ronell, designer R I C H A R D   E C K E R S L E Y and compositor Michael Jensen – is in the grip of some fiendish gremlin playing havoc with the telephone system.

**8.**
"The first consideration
of typography is to be
clearly read", debate,
Chartered Society of Designers,
London, 11 March 1991.

Wolfgang Weingart
Poster. 1977

¶Ambitious publishing projects such as *Emigre* and *The telephone book* suggest that the tradition of experimental typography initiated by Futurism, Dada and the Bauhaus, and sustained by the work of

ROBERT MASSIN
WOLFGANG WEINGART
WARREN LEHRER

Robert Massin
Page from Ionesco's play,
*The bald prima donna*

and others, is still being refreshed. None of these projects is part of the typographic mainstream, or reaches a particularly wide readership, yet they are exerting an influence well beyond their milieu. The textual designs and many of the posters featured in *Typography now: the next wave* make large demands on their readers, but they make equally large demands on their designers. If this kind of typography is not to become simply an exercise in style, or fashionable deconstruction, then

**designers must** be able to
**function as visual editors**

who can bring acute perception to their readings of the text. In some cases (*Emigre* and 8 v o 's magazine, *Octavo*, are examples) the designer might combine the role of editor and typographer. If this is not possible, then author and typographer must work together much more closely than is usually the case

**to establish
and amplify
textual meaning.**

Only then will there be a satisfying relationship between typographic expression and text.

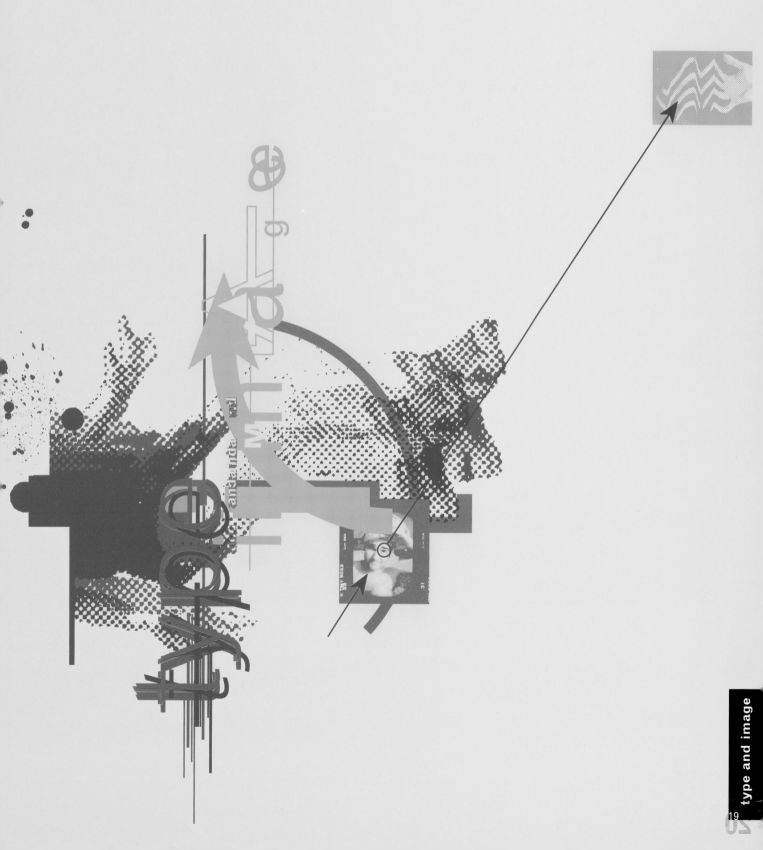

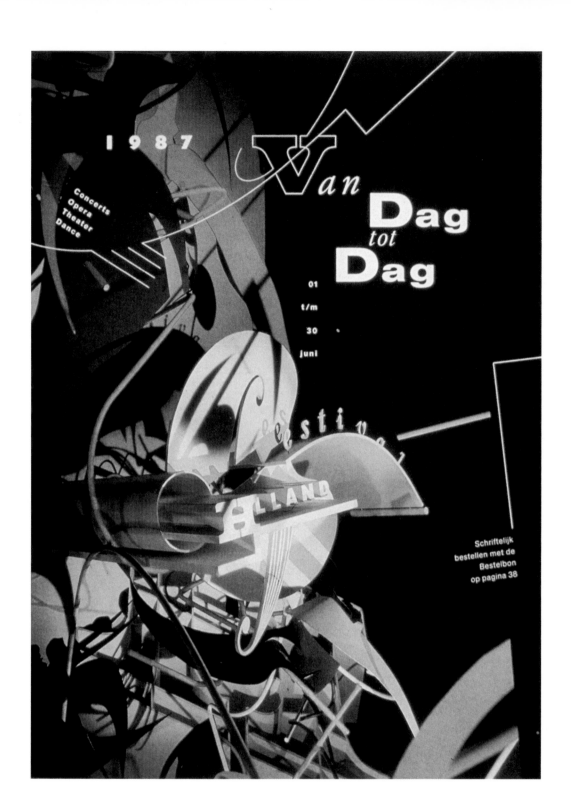

*Van dag tot dag* (From day to day). Festival magazine cover
Holland Festival, the Netherlands, 1987
Design Robert Nakata Studio Dumbar
Photography: Lex van Pieterson

*Concertos for Orchestra*. CD cover
Decca, UK, 1989
Design Nick Bell
Art director: Ann Bradbeer
Photography: Jim Friedman

*Newsprint*. Magazine cover. VRG
The Netherlands, 1990
Design Will de l'Ecluse
Ingeborg Bloem, UNA

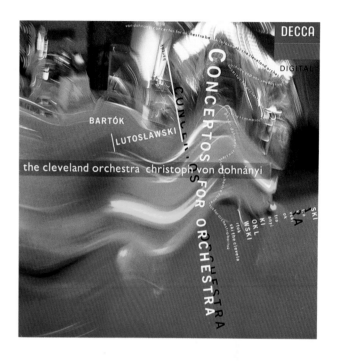

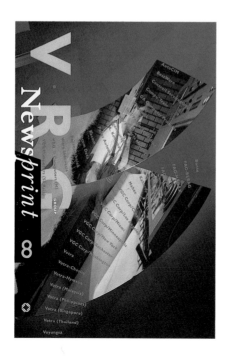

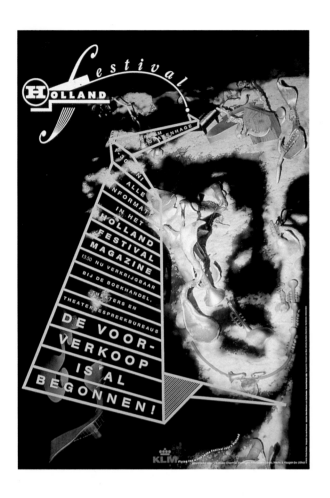

left: *De voor-verkoop is al begonnen!*
(The pre-sale has begun!)
Poster. Holland Festival, The Netherlands, 1988
Design Vincent van Baar, Hans Meijboom
Studio Dumbar
Photography: Lex van Pieterson

below: Farewell party invitation. Rijksmuseum,
The Netherlands, 1989
Design Eric Nuyten
Studio Dumbar

opposite: *Programme 1987.* Cover
Holland Festival, The Netherlands, 1987
Design Robert Nakata
Studio Dumbar
Photography: Lex van Pieterson

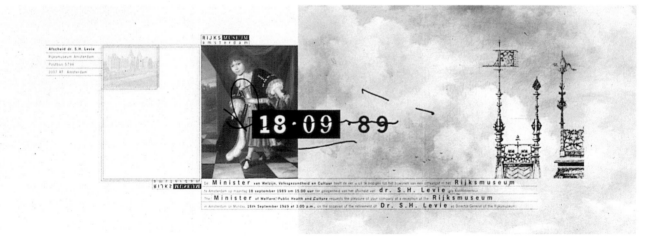

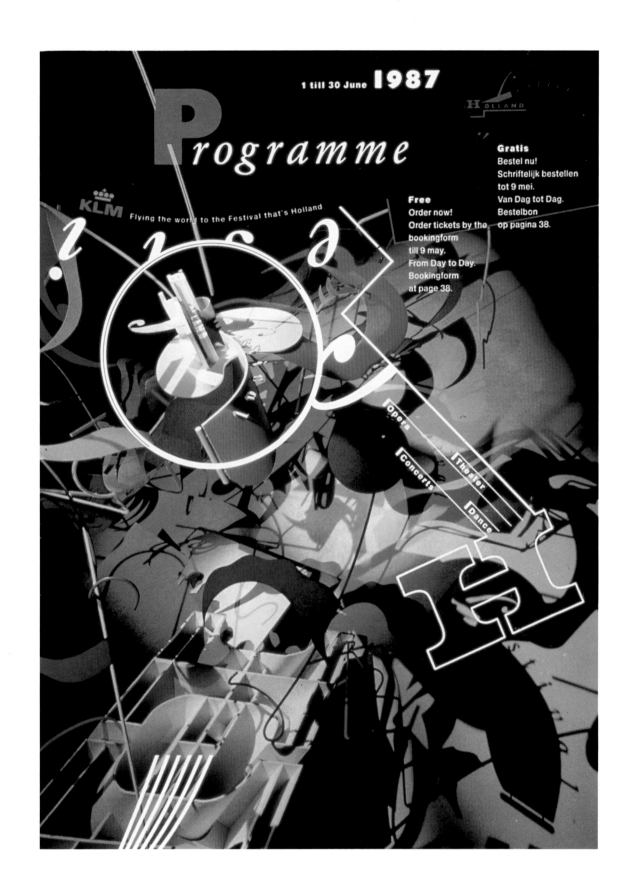

1 till 30 June **1987**

# **P**rogramme

H OLLAND

KLM Flying the world to the Festival that's Holland

**Free**
Order now!
Order tickets by the bookingform till 9 may.
From Day to Day.
Bookingform at page 38.

**Gratis**
Bestel nu!
Schriftelijk bestellen tot 9 mei.
Van Dag tot Dag.
Bestelbon op pagina 38.

Opera

Concerts

Theater

Dance

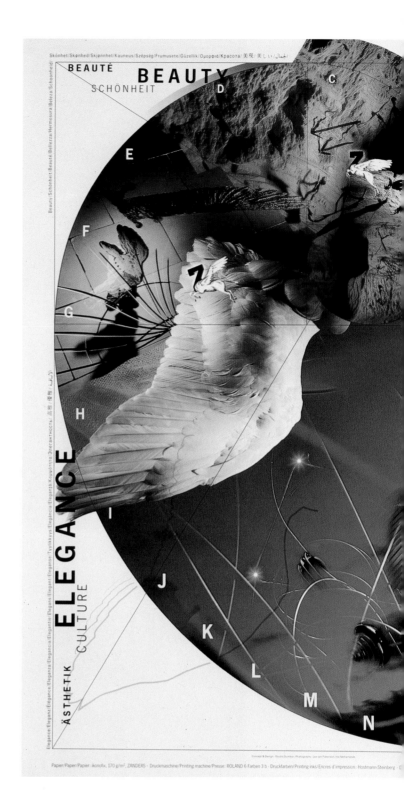

*Paper stories*. Promotional poster
Zanders, Germany, 1990
Design Helene Bergmans
Ton van Bragt
Alan Chandler
Studio Dumbar
Illustration: Henk Bank
Photography: Lex van Pieterson

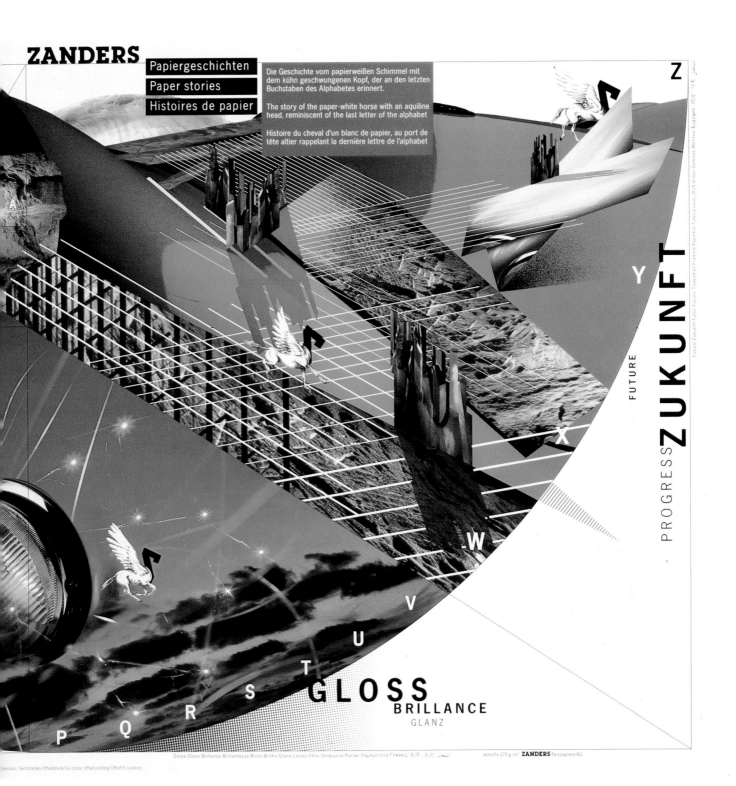

# ZANDERS

Papiergeschichten
Paper stories
Histoires de papier

Die Geschichte vom papierweißen Schimmel mit dem kühn geschwungenen Kopf, der an den letzten Buchstaben des Alphabetes erinnert.

The story of the paper-white horse with an aquiline head, reminiscent of the last letter of the alphabet

Histoire du cheval d'un blanc de papier, au port de tête altier rappelant la dernière lettre de l'alphabet

Z

FUTURE

PROGRESS **ZUKUNFT**

Y

X

W

U

V

P Q R S T **GLOSS**

BRILLANCE

GLANZ

Gloss/Glanz/Brillance/Brillantezza/Brilho/Brilho/Glans/Loisto/Fény/Strălucire/Parlak/Λαμπρότητα/Глянец/光沢/光澤/لمعان  ikonofix 170 g/m² **ZANDERS** Feinpapiere AG

pression: Sechsfarben Offsetdruck/Six colour offset printing/Offset 6 couleurs

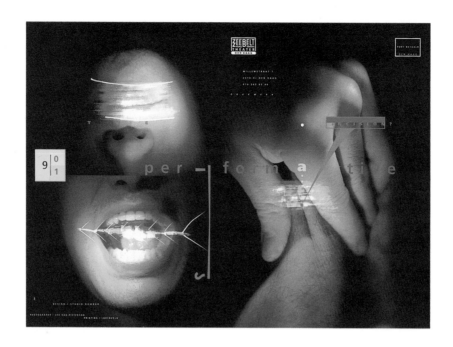

above: *Performative - Incision?*
Monthly mailer. Zeebelt Theatre,
The Netherlands, 1990
Design Allen Hori
Studio Dumbar
Photography: Lex van Pieterson

opposite: *Largo Desolato*. Poster
Bristol Old Vic, UK, 1986
Design Hans Bockting
Photography: Reinier Gerritsen

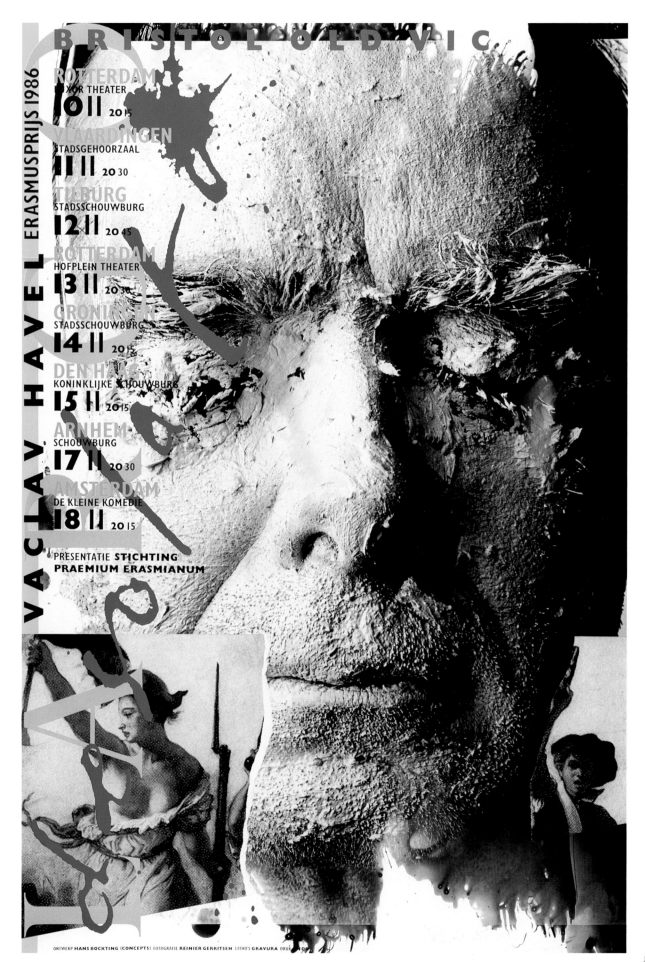

BRISTOL OLD VIC

VACLAV HAVEL ERASMUSPRIJS 1986

ROTTERDAM
LUXOR THEATER
10 II  2015

VLAARDINGEN
STADSGEHOORZAAL
11 II  20 30

TILBURG
STADSSCHOUWBURG
12 II  20 45

ROTTERDAM
HOFPLEIN THEATER
13 II  20 30

GRONINGEN
STADSSCHOUWBURG
14 II  20 15

DEN HAAG
KONINKLIJKE SCHOUWBURG
15 II  20 15

ARNHEM
SCHOUWBURG
17 II  20 30

AMSTERDAM
DE KLEINE KOMEDIE
18 II  20 15

PRESENTATIE STICHTING
PRAEMIUM ERASMIANUM

ONTWERP HANS BOCKTING (CONCEPTS) FOTOGRAFIE REINIER GERRITSEN LITHO'S GRAVURA DRUK

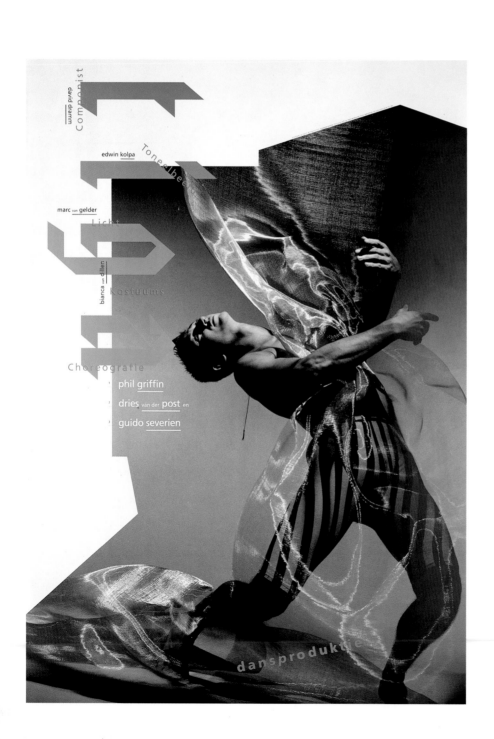

Componist
david dramm

Toneelbeeld
edwin kolpa

Licht
marc van gelder

Kostuums
bianca van dillen

Choreografie
phil griffin
dries van der post en
guido severien

dansproduktie

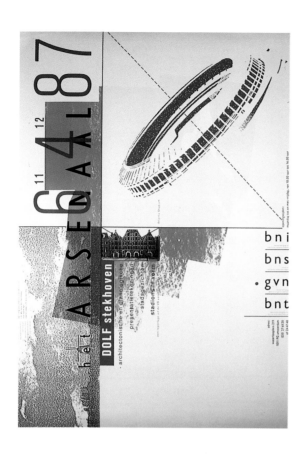

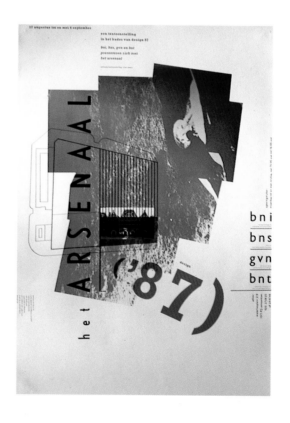

above: *Het Arsenaal/Dolf Stekhoven.* Posters
Icograda, The Netherlands, 1987
Design Armand Mevis, Linda van Deursen

opposite: *Tiga.* Poster. The Netherlands, 1990. Design Koweiden Postma
Photography: Hans Verschuuren

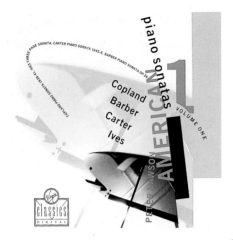

*American piano sonatas.* CD cover. Virgin Classics, UK, 1990 Design Nick Bell
Photography: Andy Rumball

Letterhead (back). UK, 1991
Design Nick Bell

Architects' brochure/poster
Daryl Jackson International, UK, 1990
Design Siobhan Keaney
Photography: Robert Shackleton

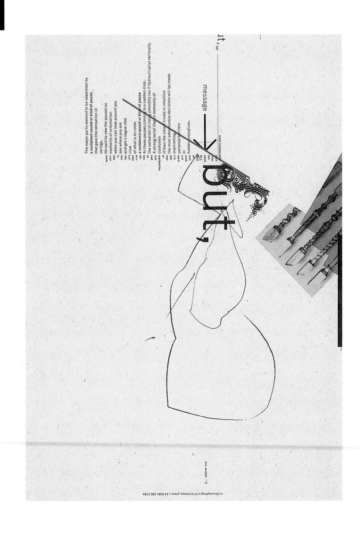

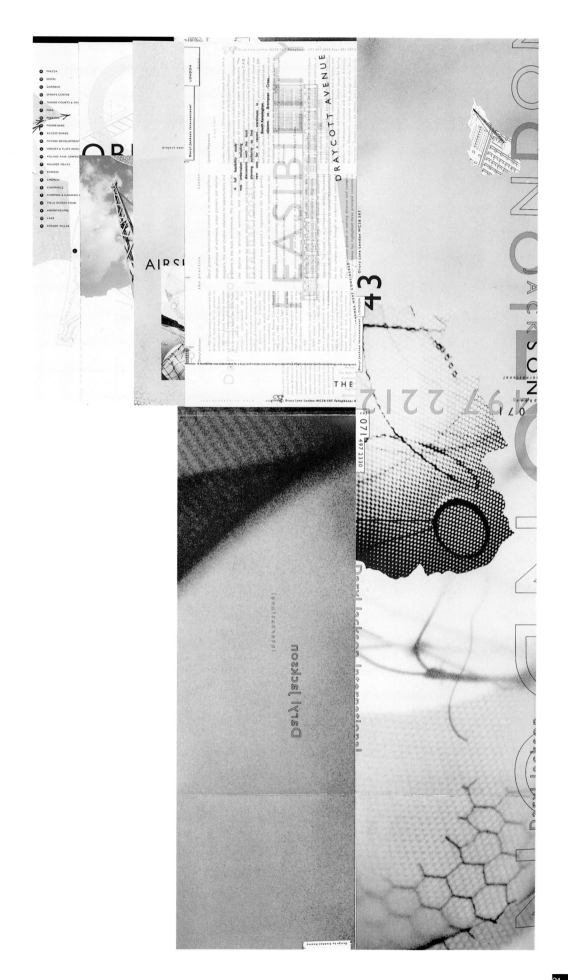

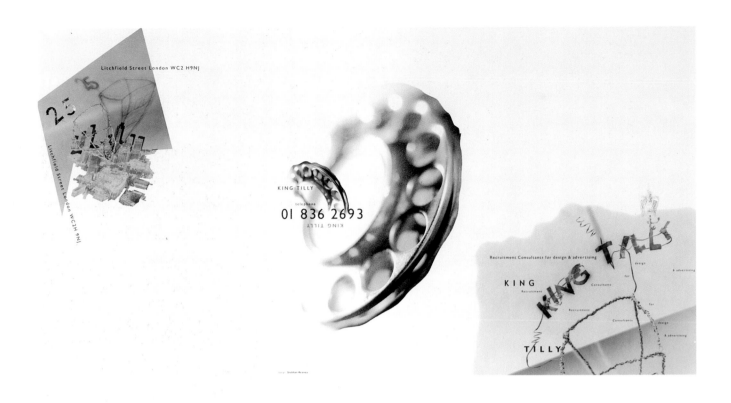

Brochure/mailer. King Tilly, UK, 1990
Design Siobhan Keaney
Photography: Robert Shackleton

Annual report. Cover. Apicorp, UK, 1988
Design Siobhan Keaney
Photography: Robert Shackleton

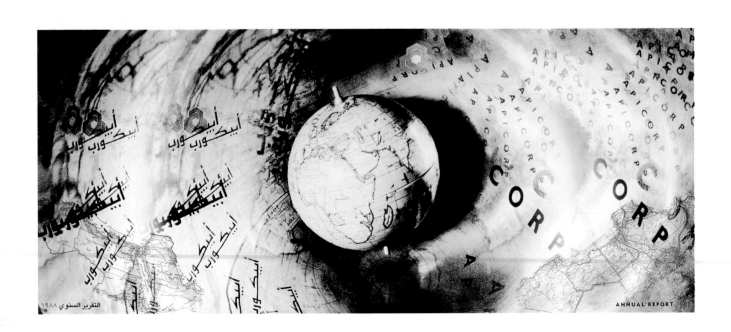

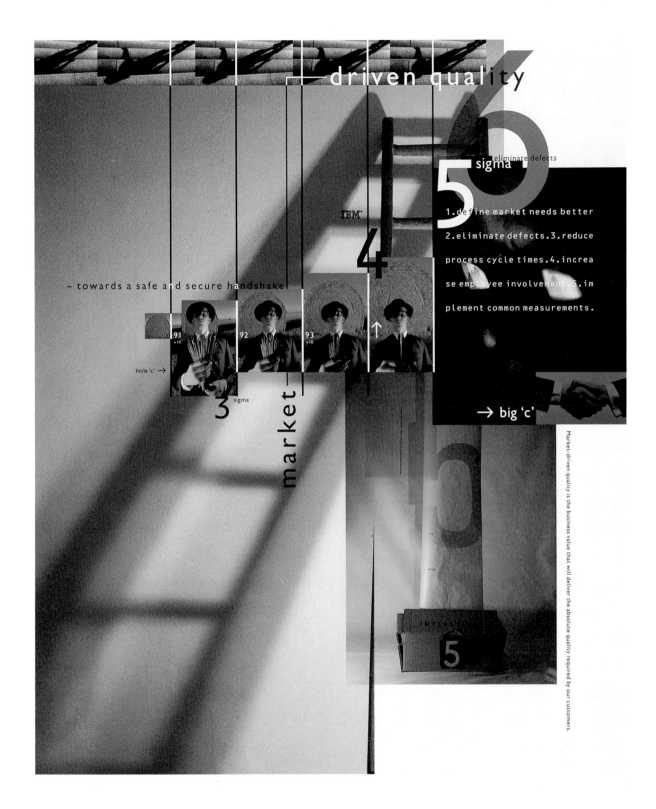

Annual review. Illustration. IBM, UK, 1991

Design Nick Bell

Photography: Andy Rumball, Nick Bell

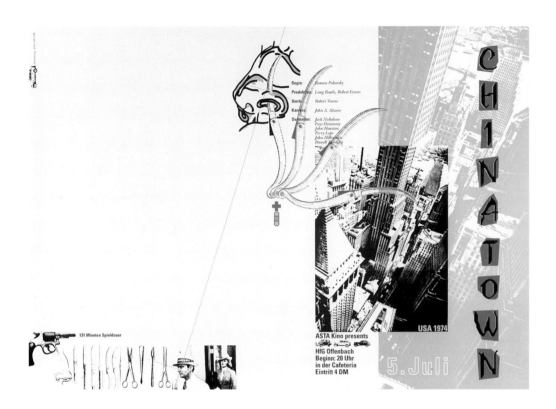

Chinatown. Film poster. Germany, 1989
Hochschule für Gestaltung
Offenbach
Design Ines Blume

opposite: 1990 calendar. PTT, The Netherlands, 1989
Design Vorm Vijf

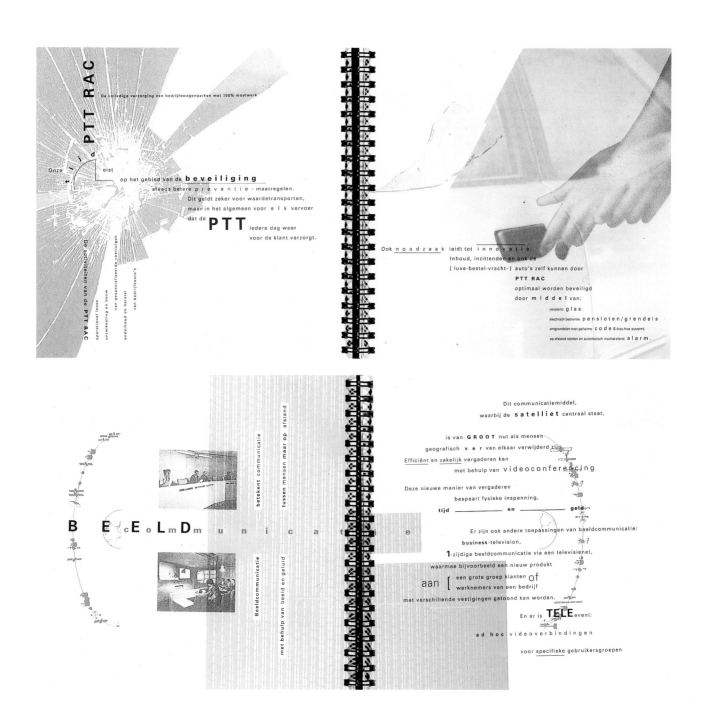

PTT RAC

De volledige verzorging van bedrijfswagenparken met 100% maatwerk

Onze · eist · tijd

op het gebied van de **beveiliging**
steeds betere p r e v e n t i e - maatregelen.
Dit geldt zeker voor waardetransporten,
maar in het algemeen voor e l k vervoer
dat de **PTT** iedere dag weer
voor de klant verzorgt.

De activiteiten van de PTT RAC
operational lease
ontwikkeling en bouw
van gespecialiseerde voertuigen
onderhoud en herstel
van bedrijfsauto's

Ook n o o d z a a k leidt tot i n n o v a t i e
Inhoud, inzittenden en ook de
[ luxe-bestel-vracht- ] auto's zelf kunnen door
**PTT RAC**
optimaal worden beveiligd
door m i d d e l van:
versterkt g l a s
electrisch bediende p e n s l o t e n / g r e n d e l s
ontgrendelen met geheime c o d e s (key-free systeem),
op afstand starten en automatisch inschakelend a l a r m .

B EcEoLmDmunicatie
betekent communicatie
tussen mensen maar op afstand
Beeldcommunicatie
met behulp van beeld en geluid

Dit communicatiemiddel,
waarbij de s a t e l l i e t centraal staat,
is van **GROOT** nut als mensen
geografisch v e r van elkaar verwijderd zijn
Efficiënt en zakelijk vergaderen kan
met behulp van v i d e o c o n f e r e n c i n g
Deze nieuwe manier van vergaderen
bespaart fysieke inspanning,
**tijd** en **geld**
Er zijn ook andere toepassingen van beeldcommunicatie:
**business**-television,
**1**-zijdige beeldcommunicatie via een televisienet,
waarmee bijvoorbeeld een nieuw produkt
aan [ een grote groep klanten of
werknemers van een bedrijf
met verschillende vestigingen getoond kan worden.
En er is **TELE** event:
ad hoc v i d e o v e r b i n d i n g e n
voor specifieke gebruikersgroepen

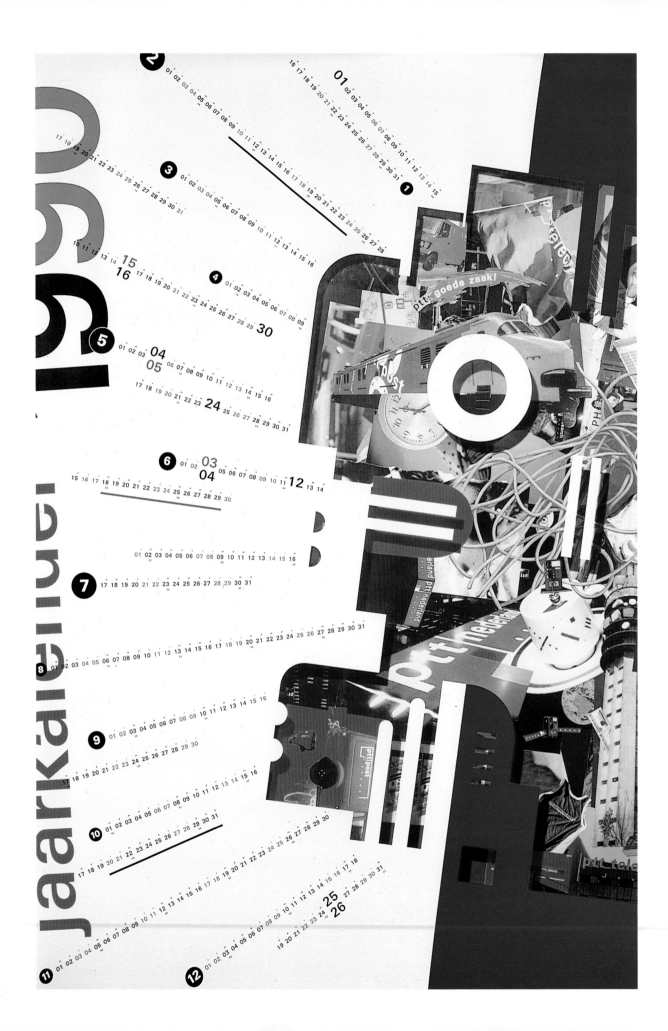

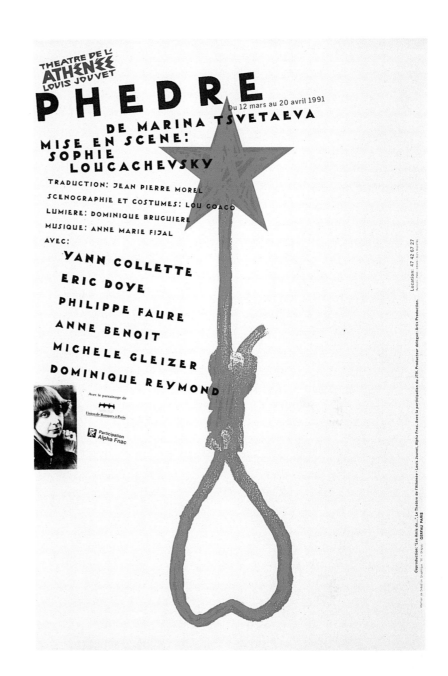

*Phedre.* Poster. Theatre de l'Athénée Louis Jouvet, France, 1991

Design Dirk
Behage
Pierre Bernard
Fokke Draaijer

Atelier de Création Graphique-Grapus

opposite: 1990 calendar. Poster. PTT, The Netherlands, 1990

Design Vorm Vijf

*It feels like a bad play.* Two-sided poster
Emigre Graphics, USA, 1989
Design/photography Allen Hori

opposite: *Cranbrook design: the new discourse*
Poster. USA, 1990
Design P. Scott Makela
Cranbrook Academy of Art

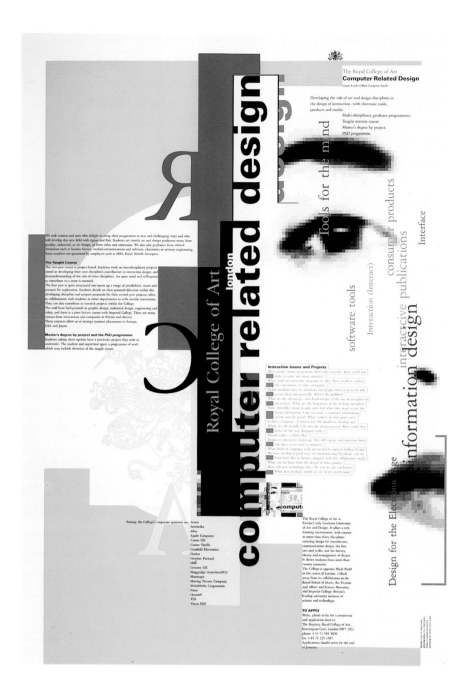

*Computer related design.* Poster
Royal College of Art, UK, 1991

Design Why Not Associates

Photography: Nick Harrington

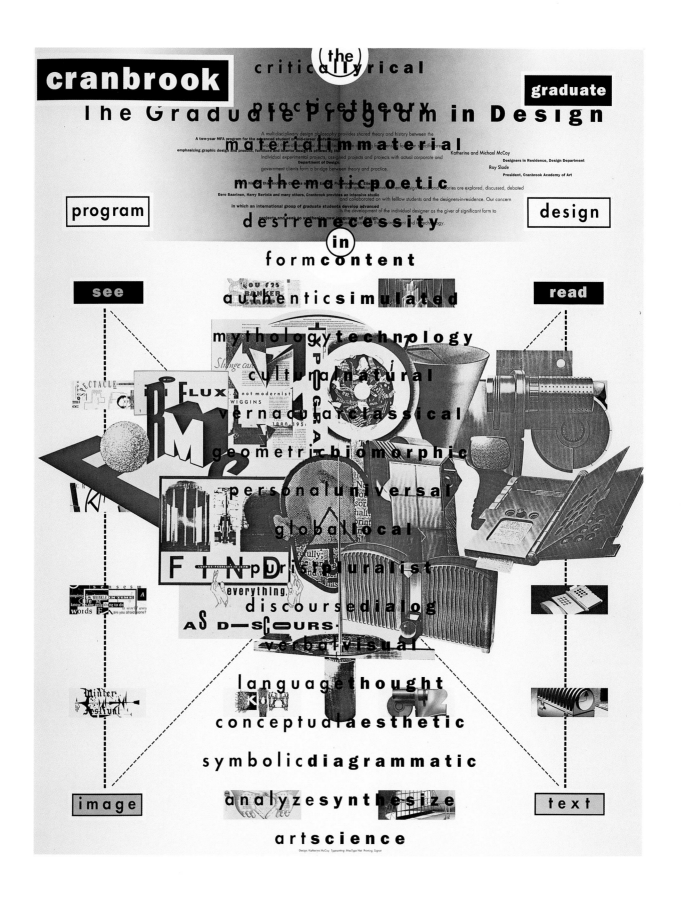

*The Cranbrook graduate program in design.* Poster
Cranbrook Academy of Art, USA, 1989
Design Katherine McCoy

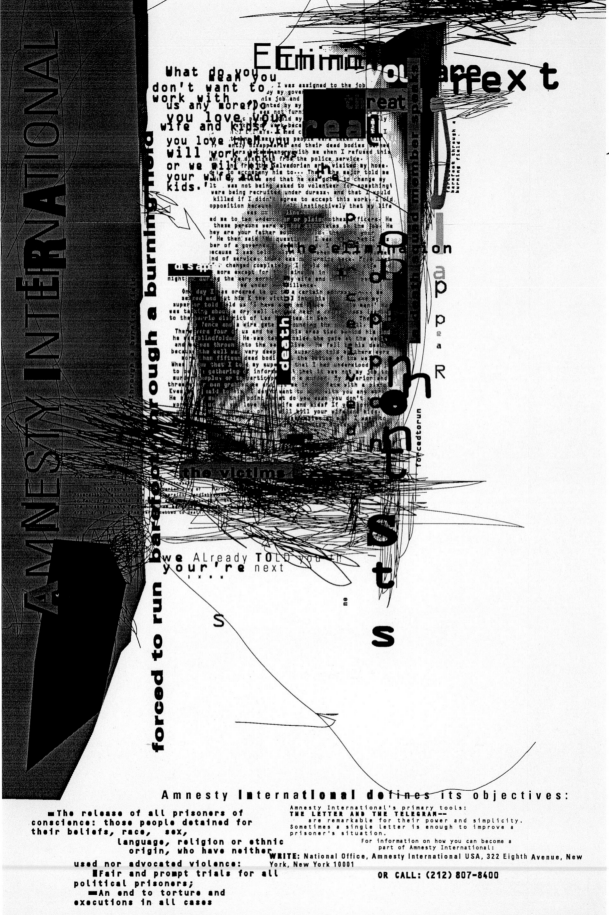

Amnesty International. Poster. USA, 1991. Design Joan Dobkin Cranbrook Academy of Art

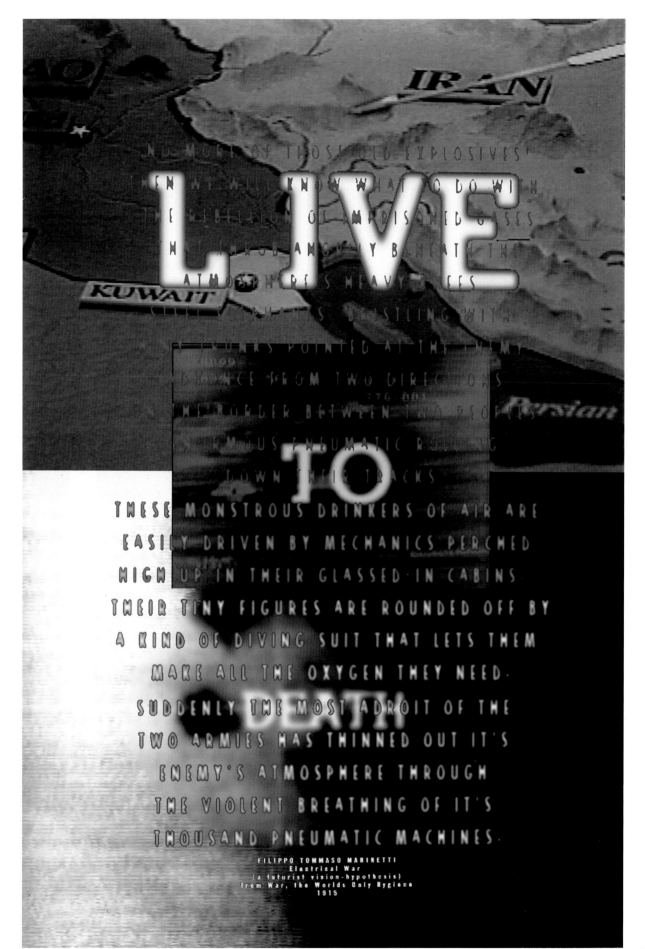

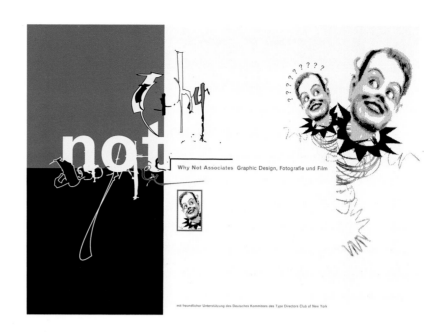

above: Exhibition invitation. UK, 1991

right: *Next Directory Preview*. Catalogue cover. Next, UK, 1991

Design Why Not Associates

Photography: Why Not Associates,
Rocco Redondo

*Lamp/Feel*. Poster. USA, 1991

Design Mark D. Sylvester

Cranbrook Academy of Art

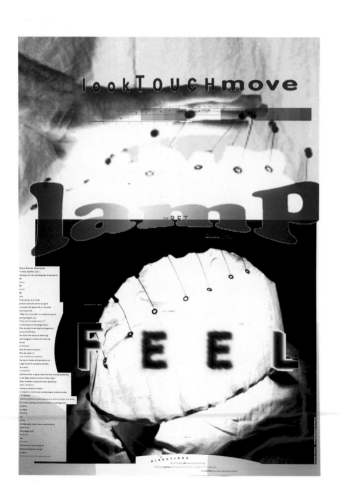

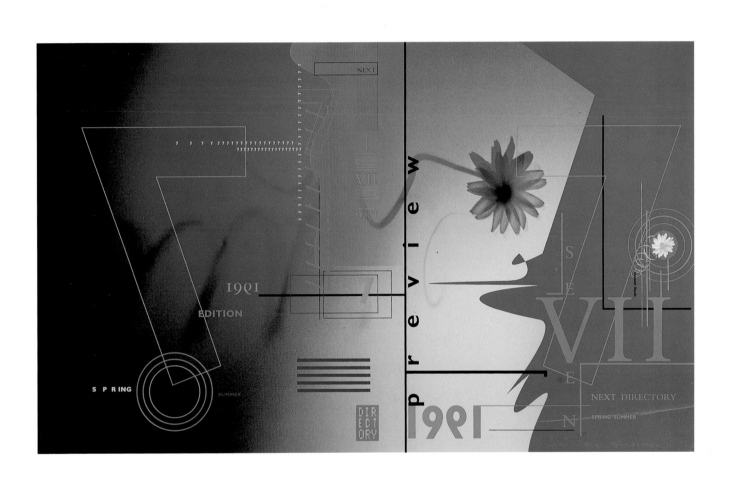

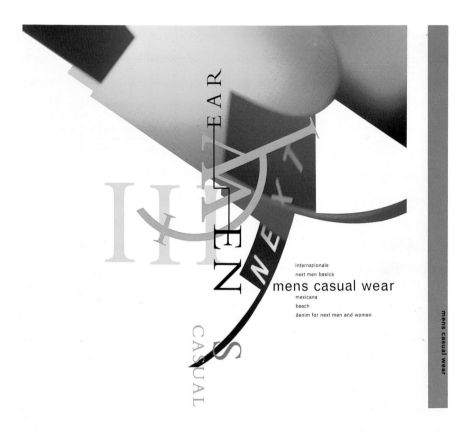

internazionale
next men basics
mens casual wear
mexicana
beach
denim for next men and women

mens casual wear

*Next Directory 5*. Section divider. Next, UK, 1990
Design Why Not Associates
Photography: Why Not Associates,
Rocco Redondo

opposite: *Morris Brose: a sustained vision*
Poster/mailer (front)
Detroit Focus Gallery, USA, 1987
Design Edward Fella

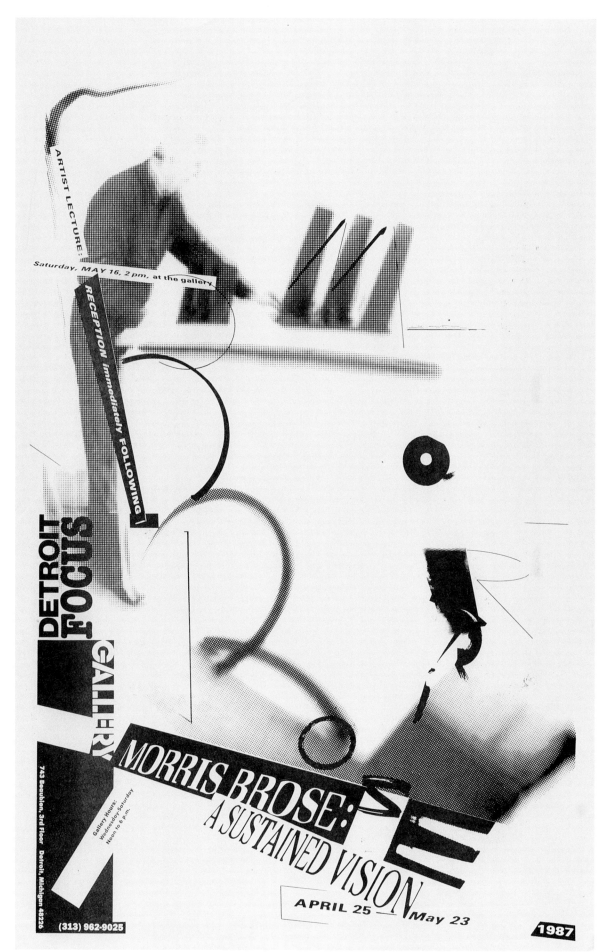

ARTIST LECTURE:

Saturday, MAY 16, 2 pm, at the gallery

RECEPTION immediately FOLLOWING

DETROIT FOCUS GALLERY

743 Beaubien, 3rd Floor   Detroit, Michigan 48226

Gallery Hours:
Wednesday-Saturday
Noon to 6 p.m.

(313) 962-9025

MORRIS BROSE: A SUSTAINED VISION

APRIL 25 — May 23

1987

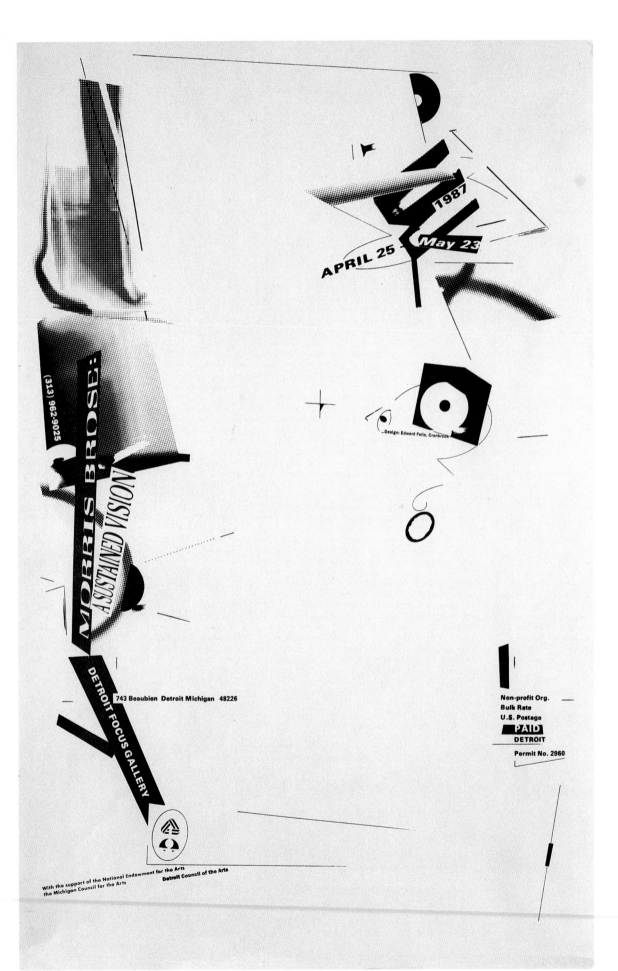

**MORRIS BROSE:**
**A SUSTAINED VISION**

(313) 962-9025

DETROIT FOCUS GALLERY

743 Beaubien  Detroit Michigan  48226

APRIL 25 – May 23 1987

~Design: Edward Fella, Cranbrook

Non-profit Org.
Bulk Rate
U.S. Postage
**PAID**
DETROIT

Permit No. 2960

With the support of the National Endowment for the Arts
the Michigan Council for the Arts        **Detroit Council of the Arts**

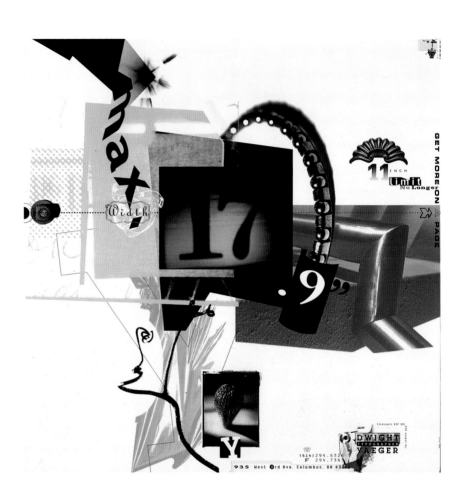

Promotional poster. Dwight Yaeger Typographer, USA, 1991
Design John Weber

opposite: *Morris Brose: a sustained vision*
Poster/mailer (back)
Detroit Focus Gallery, USA, 1987
Design Edward Fella

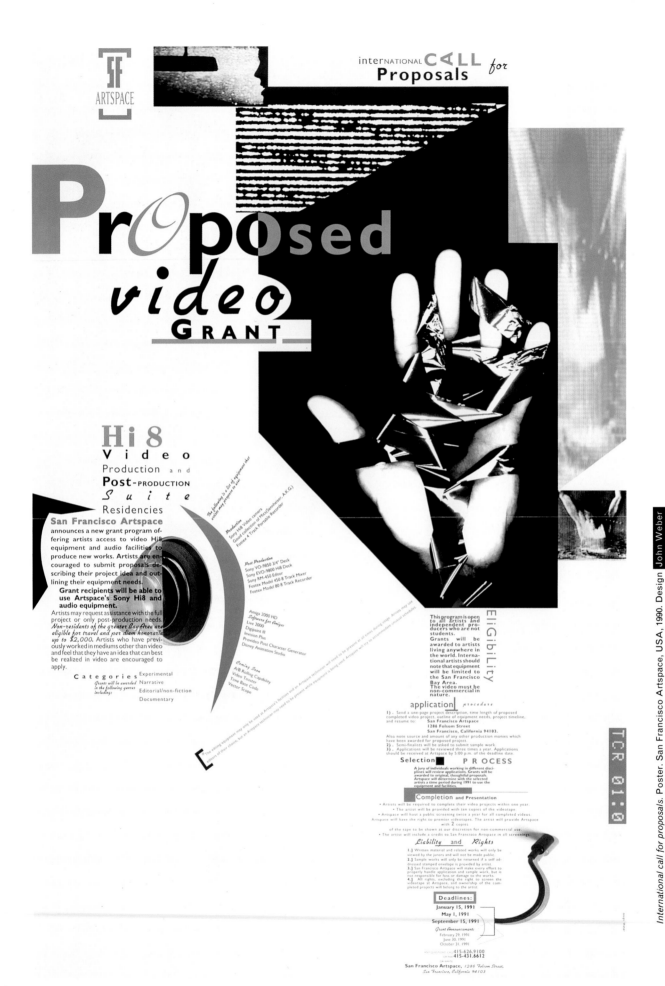

Non-Stop

design circus

(non-stop design)

CSCA Guest Speaker

RUDY
VANDERLANS
(em'ə grā')

EMIGRE

mag
azin
e

April
**19**
THURSDAY  6:30 Social hour
7:30 ANNOUNCEMENTS
**7:45** presentation

AT
THE PHOTOGRAPHIC ILLUSTRATORS
GREEN MEADOWS CORPORATE PARK
404 ENTERPRISE DRIVE
WESTERVILLE

oh

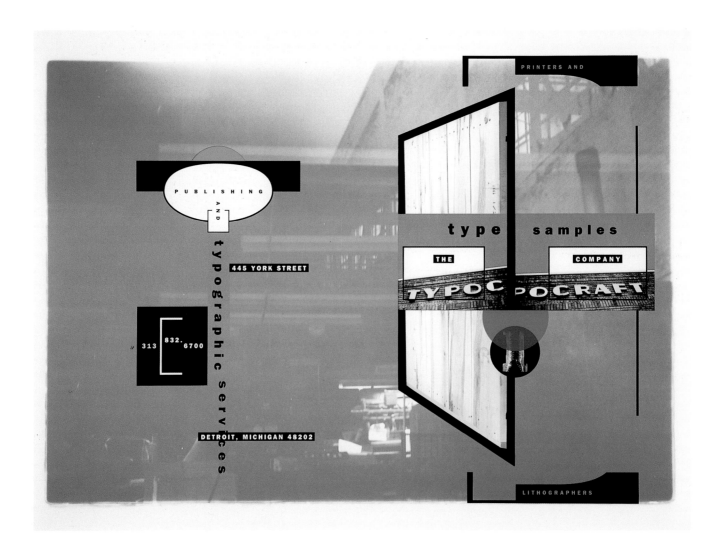

PRINTERS AND

PUBLISHING

AND

typographic services

445 YORK STREET

313 832. 6700

DETROIT, MICHIGAN 48202

type samples

THE

COMPANY

TYPOC DOCRAFT

LITHOGRAPHERS

left: Type samples poster
The Typocraft Company, USA, 1990
Design Allen Hori

right: Advertisement
Gonzgraphics, USA, 1990
Design Barry Deck
Photography: Charles Field

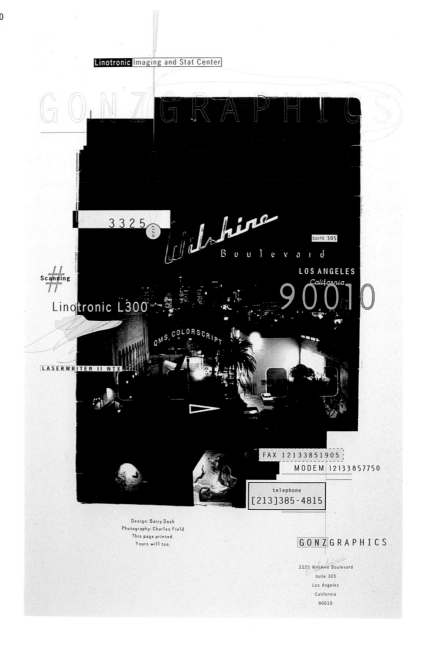

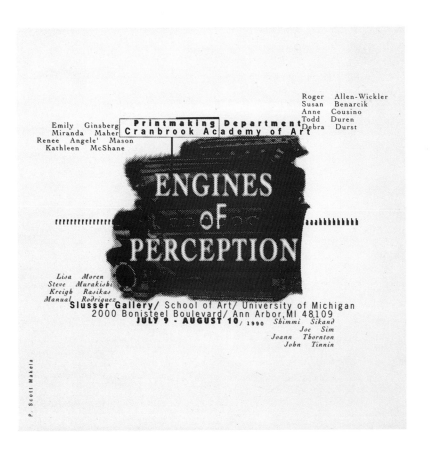

*Engines of perception.* Exhibition invitation
Cranbrook Academy of Art, USA, 1990
Design P. Scott Makela

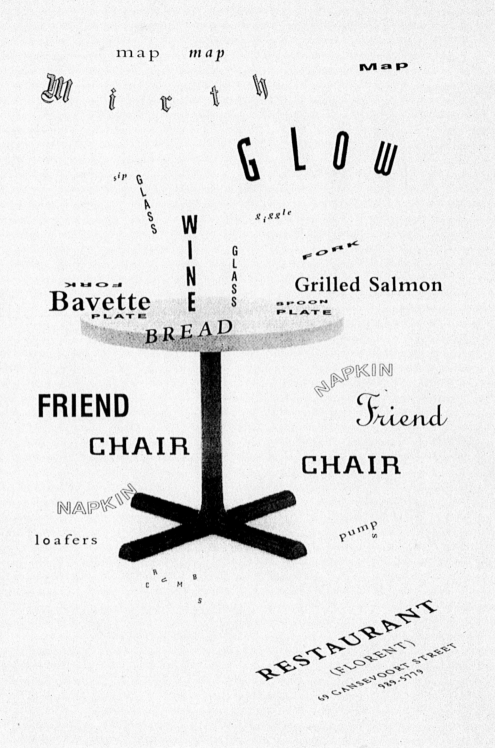

*Mirth*. Postcard
Restaurant Florent, USA, 1989
Design Marlene McCarty, Tibor Kalman M&Co

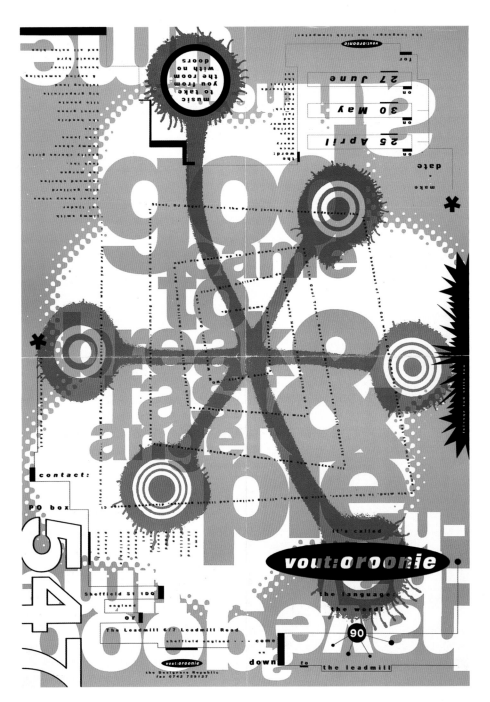

above: *Vout:oroonie*
Club poster/flyer. UK, 1990
Design Designers Republic

opposite: *Fact Twenty Two*. Poster. USA, 1990. Design Rudy VanderLans, James Towning

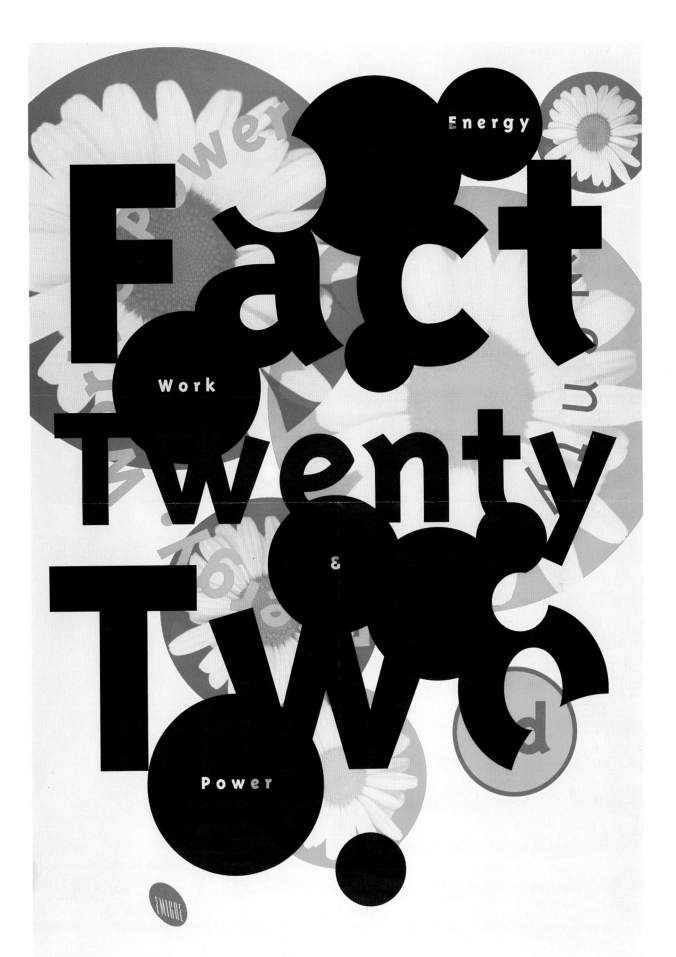

Fact Twenty Two

Energy

Work

Power

&

EMIGRE

**Public Enemy**'s first record, *Yo! Bumrush the Show*, went gold. Their second record, *It Takes a Nation of Millions to Hold Us Back*, went platinum. The single "Fight the Power" (from their third and most recent album, *Fear of a Black Planet*) was the musical theme of Spike Lee's *Do the Right Thing*. *Fear of a Black Planet* went platinum in one week. These figures might not be so impressive if the act were a middle-of-the-road act, but Public Enemy pulls no punches, and there is no shortage of controversy over their lyrics. They have become cultural heroes, representing the truth of urban life in no uncertain terms: "Elvis was a hero to most/but he never meant shit to me you see/Straight up racist that sucker was/Simple and plain/Motherfuck him and John Wayne"—from the single "Fight the Power."

In early 1983 a mobile D.J. collective known as Spectrum City was roaming around Roosevelt, Long Island, playing hip-hop in the parks and broadcasting their highly influential Super Spectrum Mixx Show on the Long Island radio station WBAU every Saturday night. At the forefront of all the action was a powerhouse jester/M.C. named Flavor Flav, whose antics and energy brought him into local prominence. It was also in Spectrum City that **Flavor Flav** began his collaboration with producer Hank Shocklee and another resident of the 'Velt, named Chuck D. Chuck had studied the speech patterns of minister Louis Farrakhan, and by blending this dynamic oratory with a keen political consciousness and a Madison Avenue knack for phrasemongering, Chuck established himself as one of the most powerful voices in rap. In 1986 Flavor Flav, Chuck D, and a D.J. named Terminator X formed Public Enemy. As his name suggests, Flavor Flav was the perfect counterpart to Chuck D's heavily militant, hard-core approach to rap. Sometimes Flavor Flav adds spice, accent, or salt, but most often his voice is inserted as a kind of hydraulic adrenaline boost, loopy and cartoonlike against Chuck's steady ahead drilling. A master at playing "the dozens" (a ritual requiring one's wit to out-insult your opponent), Flavor Flav can be as biting as he is hilarious. But as he proves on the record hit single "911 is a Joke," when Flavor Flav takes over the role of lead rapper, he commands serious respect.

i'm black and i'm proud i'm ready and hyped plus I'm amped most of my heroes don't appear on no stamps sample a look back you look and find nothing but rednecks for 400 years if you check don't worry be happy was a number one jam...

above: *Interview.* Magazine pages
Brant Publications, USA, 1990
Creative director: Tibor Kalman
Design: Kristin Johnson
Photography: Josef Astor

**athol** fugard gives the impression that **doing** the **right** thing is **easy,** that doing **the** right thing **makes** you **feel** alive, that **it** is as **easy** as breathing to **know** the **right** way from the **wrong** way.

*Interview*. Magazine pages
Brant Publications, USA, 1990
Creative director Tibor Kalman
Design Kristin Johnson
Photography: David Lee

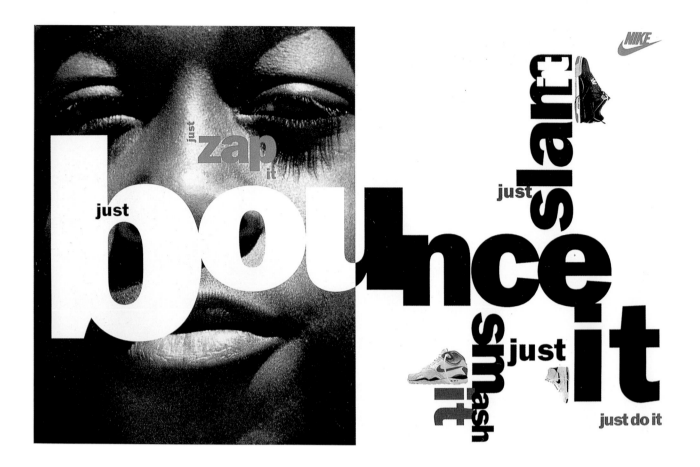

above: *Just slam it*

Advertising campaign. Nike, USA, 1989

Design Neville Brody

Agency: Wieden and Kennedy

*Interview*. Magazine pages
Brant Publications, USA, 1990
Creative director Fabien Baron
Photography:
Wayne Maser

IGGY
pop

rob lowe

left: *Interview*. Magazine pages
Brant Publications, USA, 1990
Creative director Fabien Baron
Photography: Albert Watson
below: *Per Lui*. Magazine pages
Condé Nast, Italy, 1990
Art director Neville Brody

**Definizione:** «La forma è l'aspetto di un oggetto, sufficiente a caratterizzarlo esteriormente». Shape, in inglese. È la struttura, la linea, il risultato di una manipolazione, di una creazione: il frutto della natura, della mano dell'uomo. È la natura, è l'uomo. È ciò che sta fuori: il racconto visivo, la sintesi di quel che sta dentro. È il disegno, il pensiero che si può toccare, la certezza; la rassicurazione che quella cosa, quell'oggetto esistono davvero. Già, ma perché la forma? Perché tentare di rappresentare la nostra vita attraverso le forme? Perché forma è tutto, e tutto ha una forma. A partire dall'universo – un'immensa cupola? – e prima ancora dal «caos», come spiega il giornalista Peter Glaser, «la forma di tutte le forme, l'inizio della storia». Che oggi ritorna nei frattali, cioè le rappresentazioni grafiche di formule ▸

opposite: *Howl* by Allen Ginsberg (German translation)
Book pages. Germany, 1991
Design Lars Ohlerich
Hochschule für Gestaltung
Offenbach

below: *Howl* by Allen Ginsberg
Book pages. Germany, 1991
Design Peter Biler
Hochschule für Gestaltung,
Offenbach

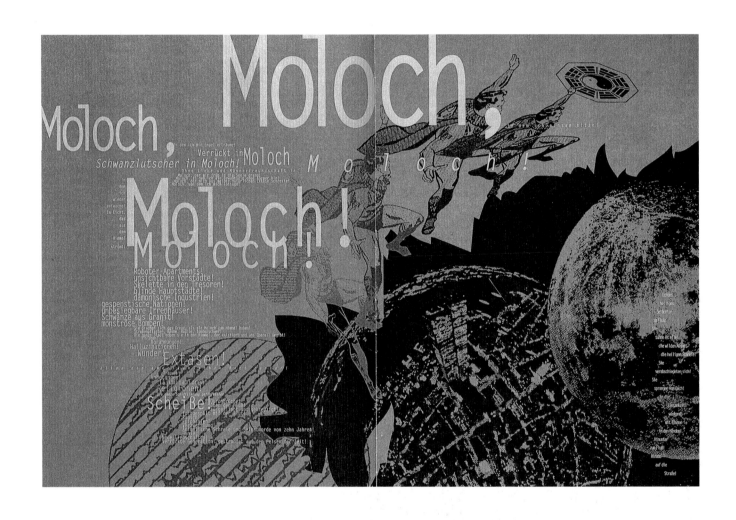

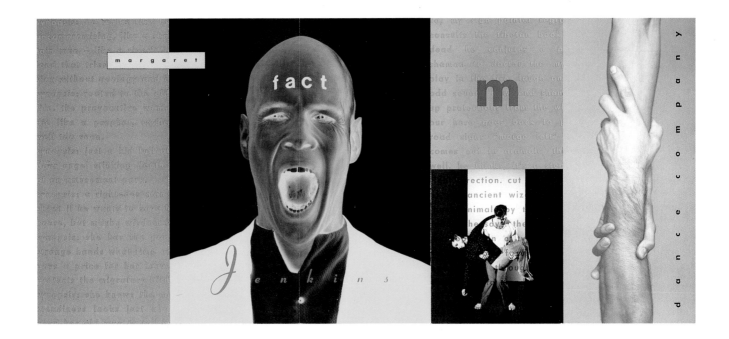

above: *Dance for the new decade*
Margaret Jenkins Dance Company, USA, 1988
Design Tom Bonauro
Photography: Ken Probst

right: *Rearrange.* Greetings card
Pillow Talk Cards, USA, 1991
Design Tom Bonauro

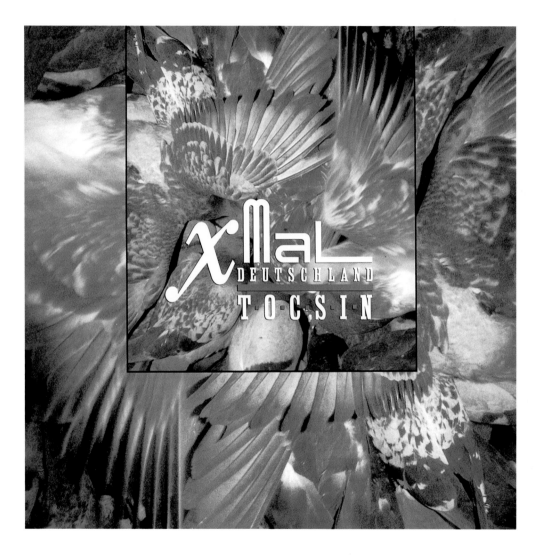

*Tocsin.* Album cover. 4AD, UK, 1984. Design Vaughan Oliver
Photography: Nigel Grierson

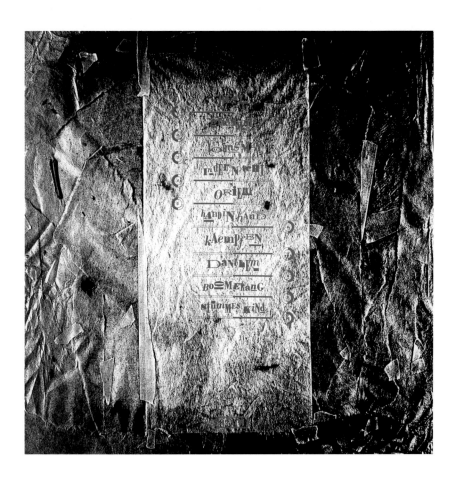

*Fetisch*. Album cover (back)
4AD, UK, 1983
Design Vaughan Oliver

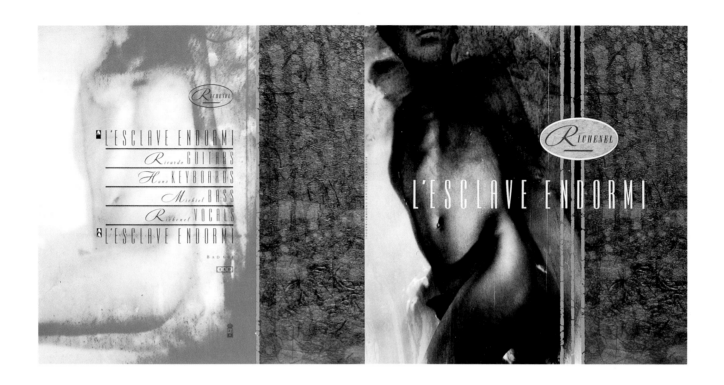

above: *L'Esclave endormi.* 12" single (front and back). 4AD, UK, 1986
Design Vaughan Oliver
Photography: Nigel Grierson

left: *Le mystère des voix Bulgares*
Album cover. 4AD, UK, 1988
Design Vaughan Oliver
Photography: Simon Larbalestier

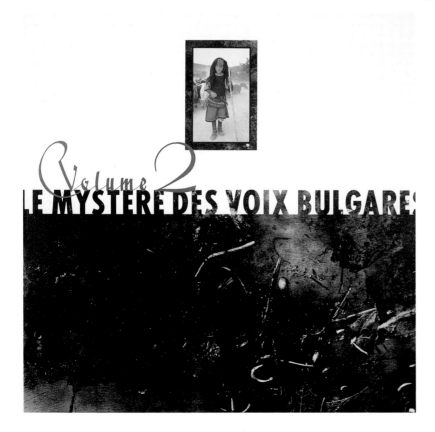

*Doolittle.* Album cover. 4AD, UK, 1989

Design Vaughan Oliver

Photography: Simon Larbalestier

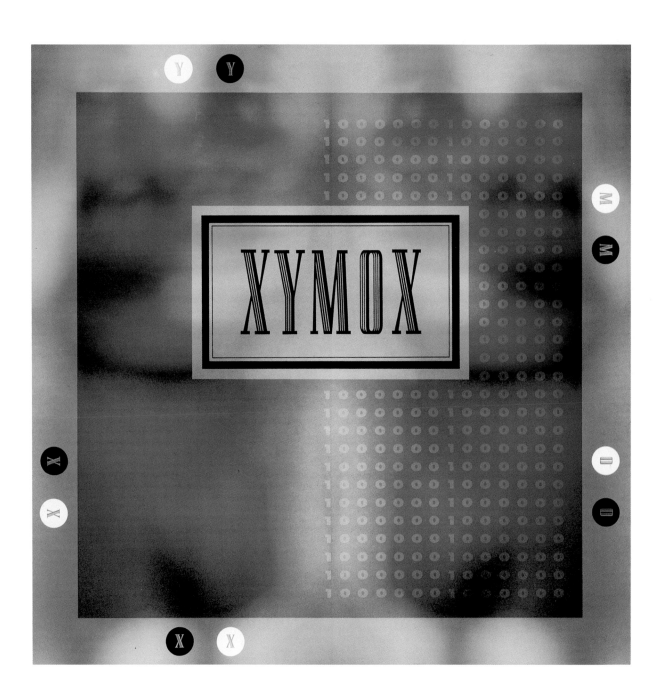

*Xymox.* 12" single cover. 4AD, UK, 1987
Design Vaughan Oliver
Photography: Jim Friedman

Black Francis: Vocals, Guitar
Kim Deal: Bass, vocals
David Lovering: Drums, vocals
Joey Santiago: Lead Guitar

Robert F. Brunner: Theremin

1 Velouria
2 Make Believe
Produced by Gil Norton
3 I've Been Waiting For You
4 The Thing

Art Direction and Design: Vaughan Oliver / v23
Photography: Simon Larbalestier
Made in England

BAD 0009

*Velouria.* 12" single cover (back). 4AD, UK, 1990. Design Vaughan Oliver Photography: Simon Larbalestier

right: Brochure. Seymour Powell. UK, 1989
Design Siobhan Keaney
Photography: Robert Shackleton

below: Price card. P.Inks LA. USA, 1989
Design Tom Bonauro

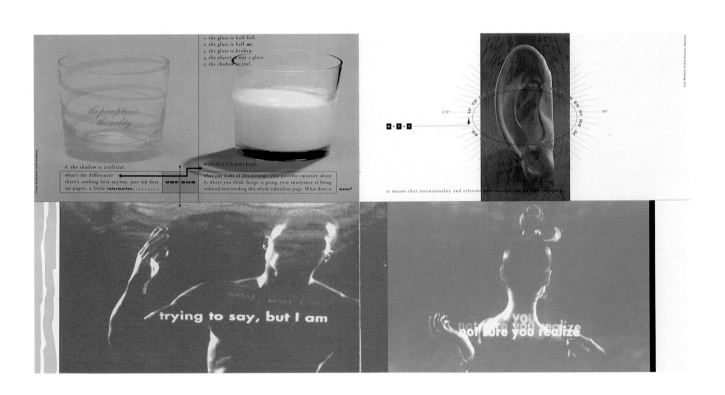

*Enter.* Call for entries
American Center for Design, USA, 1989
Design Rick Valicenti Thirst

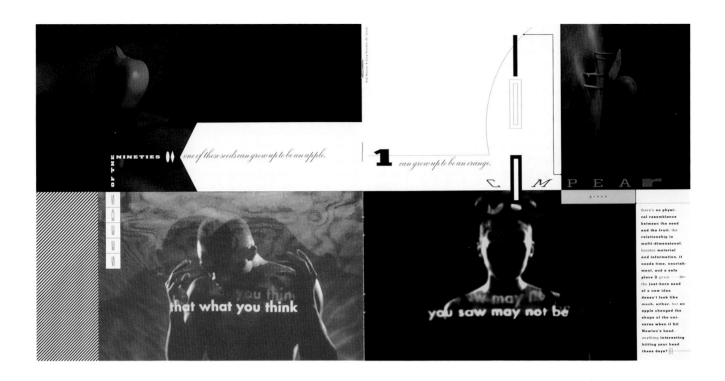

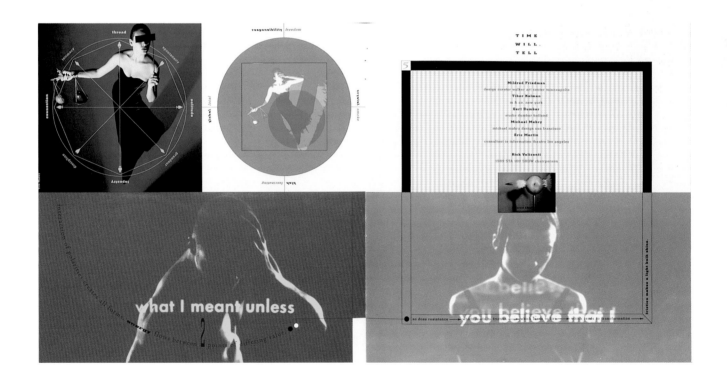

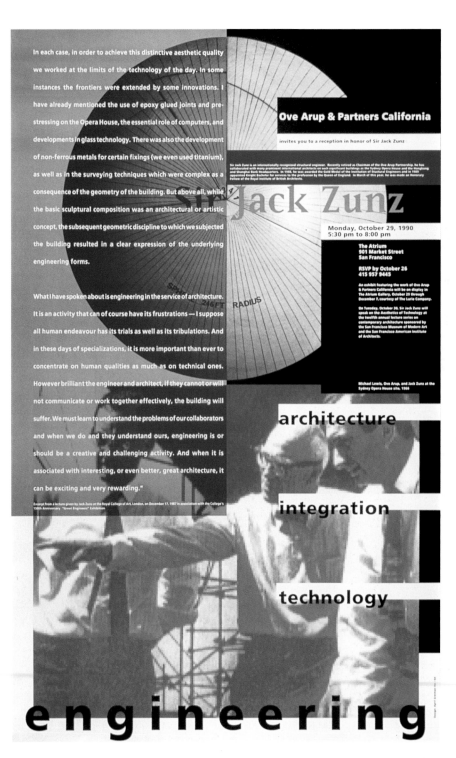

In each case, in order to achieve this distinctive aesthetic quality we worked at the limits of the technology of the day. In some instances the frontiers were extended by some innovations. I have already mentioned the use of epoxy glued joints and pre-stressing on the Opera House, the essential role of computers, and developments in glass technology. There was also the development of non-ferrous metals for certain fixings (we even used titanium), as well as in the surveying techniques which were complex as a consequence of the geometry of the building. But above all, while the basic sculptural composition was an architectural or artistic concept, the subsequent geometric discipline to which we subjected the building resulted in a clear expression of the underlying engineering forms.

What I have spoken about is engineering in the service of architecture. It is an activity that can of course have its frustrations — I suppose all human endeavour has its trials as well as its tribulations. And in these days of specializations, it is more important than ever to concentrate on human qualities as much as on technical ones. However brilliant the engineer and architect, if they cannot or will not communicate or work together effectively, the building will suffer. We must learn to understand the problems of our collaborators and when we do and they understand ours, engineering is or should be a creative and challenging activity. And when it is associated with interesting, or even better, great architecture, it can be exciting and very rewarding."

Excerpt from a lecture given by Jack Zunz at the Royal College of Art, London, on December 17, 1987 in association with the College's 150th Anniversary "Great Engineers" Exhibition

## Ove Arup & Partners California

invites you to a reception in honor of Sir Jack Zunz

Sir Jack Zunz is an internationally recognized structural engineer. Recently retired as Chairman of the Ove Arup Partnership, he has collaborated with many prominent international architects on such significant buildings as the Sydney Opera House and the Hongkong and Shanghai Bank Headquarters. In 1988, he was awarded the Gold Medal of the Institution of Structural Engineers and in 1989 appointed Knight Bachelor for services to the profession by the Queen of England. In March of this year, he was made an Honorary Fellow of the Royal Institute of British Architects.

## Sir Jack Zunz

Monday, October 29, 1990
5:30 pm to 8:00 pm

The Atrium
901 Market Street
San Francisco

RSVP by October 26
415 957 9445

An exhibit featuring the work of Ove Arup & Partners California will be on display in The Atrium Gallery, October 29 through December 7, courtesy of The Luria Company.

On Tuesday, October 30, Sir Jack Zunz will speak on the Aesthetics of Technology at the twelfth annual lecture series on contemporary architecture sponsored by the San Francisco Museum of Modern Art and the San Francisco American Institute of Architects.

Michael Lewis, Ove Arup, and Jack Zunz at the Sydney Opera House site, 1966

architecture

integration

technology

engineering

opposite:
*Sir Jack Zunz.* Invitation
Ove Arup & Partners, USA, 1990

*Workspirit.* Magazine cover. Vitra,
Switzerland, 1988
Design April Greiman

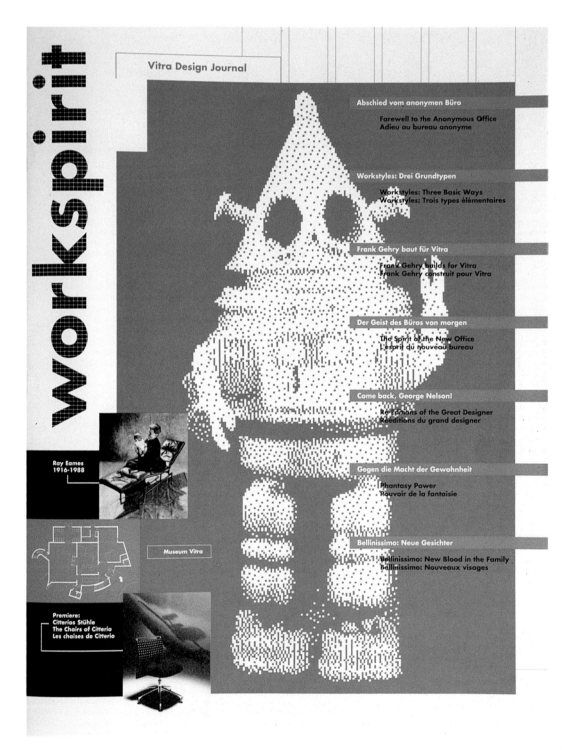

Vitra Design Journal

**Abschied vom anonymen Büro**

Farewell to the Anonymous Office
Adieu au bureau anonyme

**Workstyles: Drei Grundtypen**

Workstyles: Three Basic Ways
Workstyles: Trois types élémentaires

**Frank Gehry baut für Vitra**

Frank Gehry builds for Vitra
Frank Gehry construit pour Vitra

**Der Geist des Büros von morgen**

The Spirit of the New Office
L'esprit du nouveau bureau

**Come back, George Nelson!**

Re-Editions of the Great Designer
Rééditions du grand designer

**Gegen die Macht der Gewohnheit**

Phantasy Power
Pouvoir de la fantaisie

**Bellinissimo: Neue Gesichter**

Bellinissimo: New Blood in the Family
Bellinissimo: Nouveaux visages

Ray Eames
1916-1988

Museum Vitra

Premiere:
Citterios Stühle
The Chairs of Citterio
Les chaises de Citterio

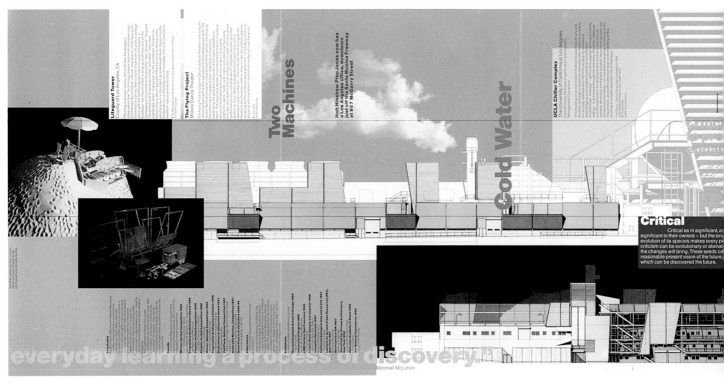
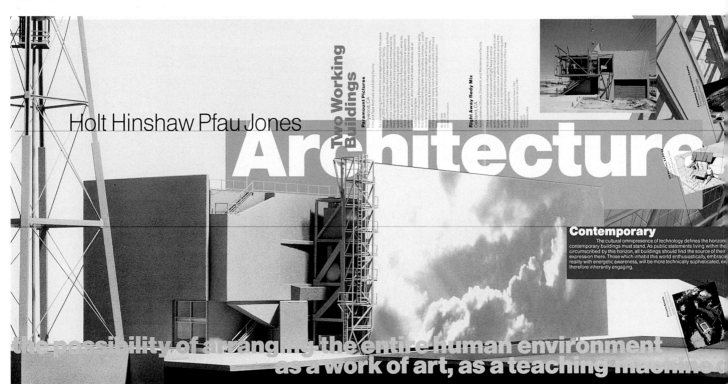

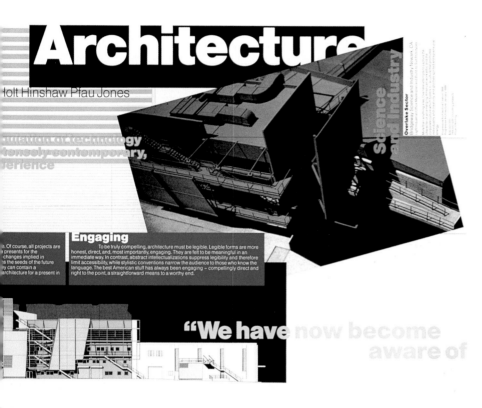

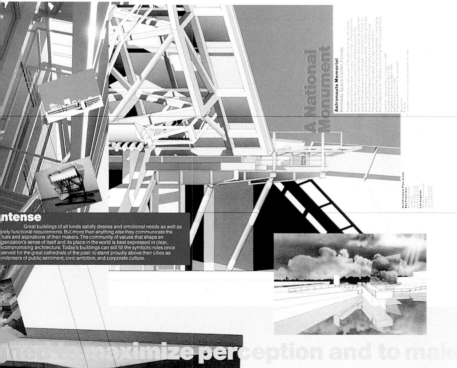

Architects' brochure/poster
(front and back). Holt Hinshaw Pfau Jones, USA, 1989
Design 8vo

making

Ched Reeder

Joseph Fenzl

Judith Crook

Tom Farrage
Bob Cunningham
David Hertz

1990

Professional Development

at SCI-ARC offers an

# S C I ARC
Southern California Institute of Architecture

Summer

opportunity for working

Coy Howard
Post, Post - The Four Best Kept Secrets of the Creative Life

Louis Naidorf
Major Highrise Office Building Workshop

directly with the most

George Sumner
Putting It All Together

actively creative people in

Michael Andrews
Fundamentals of Architectural Model Making

the discipline.

In the Spirit of Wood: A Day with a Master Craftsman
Sam Maloof

These courses combine

Graham Powell

Charles Calvo

the activities of making and

Sam Hall Kaplan

thinking in an open

experimental interchange.

Peter Shire
Art Furniture Design: Who Did What to Whom

Steven D. Ehrlich

Ron Mendleski

Nader Khalili

Kenneth Breisch
American Cities: The Chicago School

Peter Shapiro
The Finely Crafted Drawer
Wood Finishing

thinking

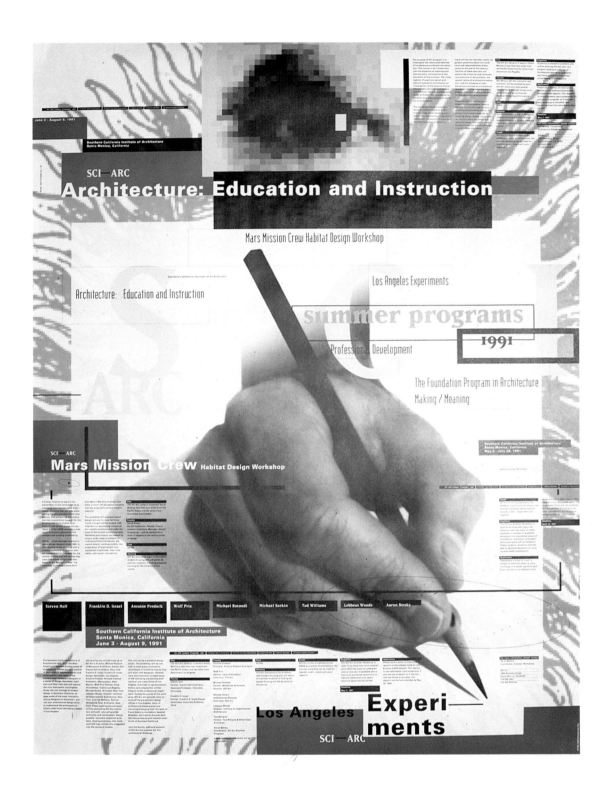

*Sci Arc: summer programs.* Poster
Southern California Institute of Architecture,
USA, 1991
opposite:
*Sci Arc: making/thinking.* Poster
Southern California Institute of Architecture,
USA, 1990
Design April Greiman

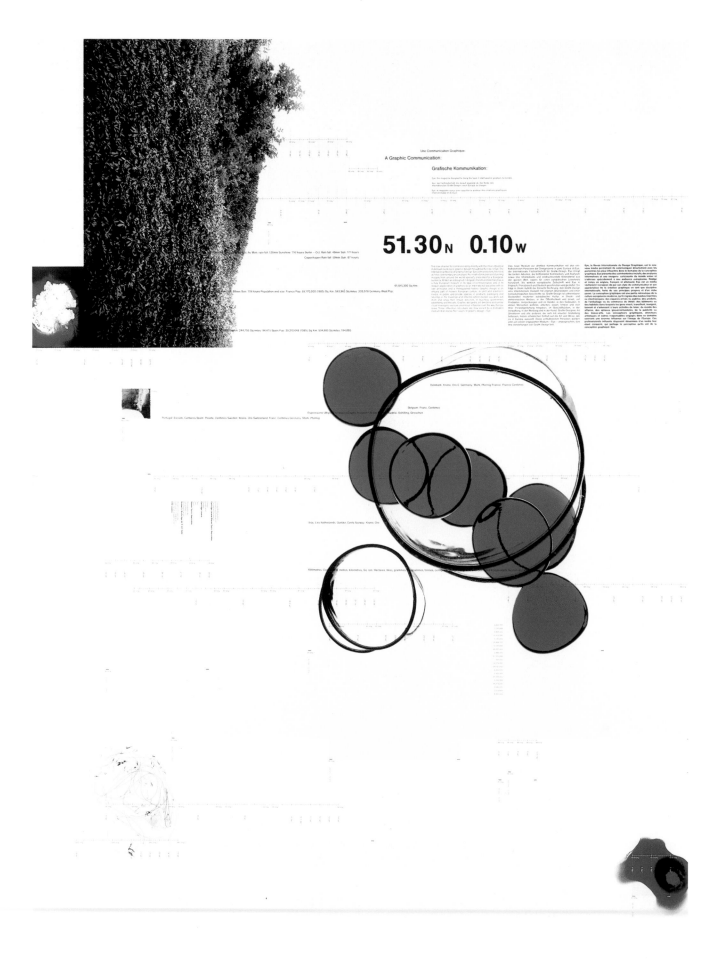

Use Communication Graphique

A Graphic Communication:

Grafische Kommunikation:

# 51.30ₙ  0.10ᴡ

opposite: *Eye magazine: a graphic communication*
Promotional poster. Wordsearch, UK, 1990
Design Cartlidge Levene
Photography: Richard J. Burbridge

*Issue.* Magazine pages
Design Museum, UK, 1991
Design Cartlidge Levene
Photography: Richard J. Burbridge

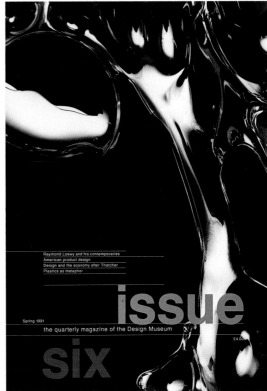

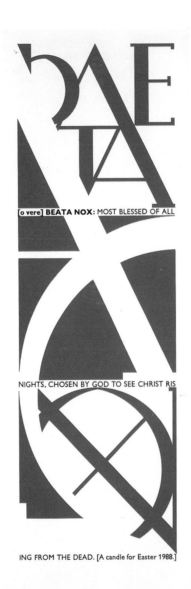

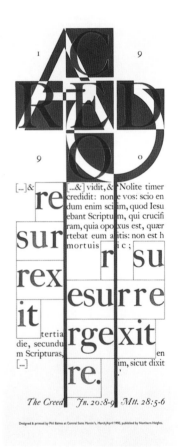

This is the night, **(hæc nox est)**, when the pillar of fire destroyed the darkness of sin. This is the night, **(hæc no x est)**, when Christians everywhere, washed clean of si n & freed from all defilement, are restored to peace & g row together in holiness. This is the night, **(hæc nox es t)**, when Jesus Christ broke the chains of death and rose triumphant from the grave.
MOST BLESSED OF ALL NIGHTS. **(O VERE BEATA NOX)**, CHOSEN BY GOD TO SEE CHRIST RISING F ROM THE DEAD.

Designed & printed by Phil Baines at the Royal College of Art, Easter 1987.

[o vere] **BEATA NOX:** MOST BLESSED OF ALL

NIGHTS, CHOSEN BY GOD TO SEE CHRIST RIS

ING FROM THE DEAD. [A candle for Easter 1988.]

Copyright Phil Baines, 1988. Published by Northern Heights.

[...]& vidit, & 'Nolite timer credidit: nonne vos: scio en dum enim sci im, quod Iesu ebant Scriptu m, qui crucifi ram, quia opo xus est, quær tebat eum a itis: non est h mortuis i c ;

re
sur
rex
it
r su
esurre
rgexit
re.

tertia die, secundu m Scripturas, [...]
en im, sicut dixit

*The Creed*  *Jn. 20:8-9*  *Mtt. 28:5-6*

Designed & printed by Phil Baines at Central Saint Martin's, March/April 1990, published by Northern Heights.

*Paschal candles*
Letterpress and silk screen
to fit 3' x 3" candle. UK, 1987-91
Design Phil Baines

This          This          This
is the night...   is the night...   is the night...

# HÆC
1 9
# NOX
9 1
# EST

...when Jesus   ...when Christ   ...when first y
Christ broke t   ians everywh   ou saved our
he chains of d   ere, washed c   fathers: you f
eath & rose tr   lean of sin &   reed the peop
iumphant fro   freed from all   le of Israel fr
m the grave.                om their slav
*Des*           ery & led the
*igned* & *prin*                m dry-shod t
*ted by Phil Ba*                hrough the se
*ines, iii 1991.*                a.   *Exsultet*

defilement, an
e restored to
peace & grow
together in h
oliness.

u          i          a

poster design: phil baines, typeface: frutiger
poster published 199_ by fontshop international. ©copyright _ 199_. phil baines

can you
& do you
want to
read me.

the real writer's mind can read
virtually anything. reconsider the old before
reaching for the new. question ideas of function...
we all have keys to the designer's hoard which...
with ? ideas...
the eye sees four fathers... let the heart rule
the head. no rules are good rules. why create
wise effecting... letters... figure... will that...
through... our force develop... forms & meaning
the more... explored in... inject the longer
... visual subject... before...-scientific
... the picture...

EX REJ OICE heavenly powers. SING, choirs of angels. EXULT, all creation around God's throne
SUL
TET
iam A
ngelic
a sJesu
sCHR

O happy fault

CHR IST tu

IST yesterday and today, the beginning and the end, OUR KiNG rba

,O necessary sin of Adam, which gained for us so great a redeemer. Most blessed of all nights, chosen by God to see CHRIST

Alpha is RIS ing fro
and O EN. Sound the trumpet of salvation.... m the
mega, al lt i m e belongs to him, and all the ages,'TO HI caelo Acc ept this EAsT eR candle, a flame divided, dead.
M B E GL rum.
ORY and power through every age for ever, AMEN. but undimmed, A PILLAR OF FIRE that grows to the glory of God. Let it mingle with the lights of heaven and continue bravely burning TO DISPEl tHe DarKNESS of this night. May the morning star which never sets find this flame still burning: CHRIST that morning star, WHO CAME BACK FROM THe DEAD. O vere beata nox.

1986

PhilBaines: March,

opposite: *F Can You . . . ?*
Poster for typographic magazine. *Fuse* issue 1, UK, 1991

*Paschal candle*
Letterpress to fit 3' x 3" candle. UK, 1986

Design  Phil Baines

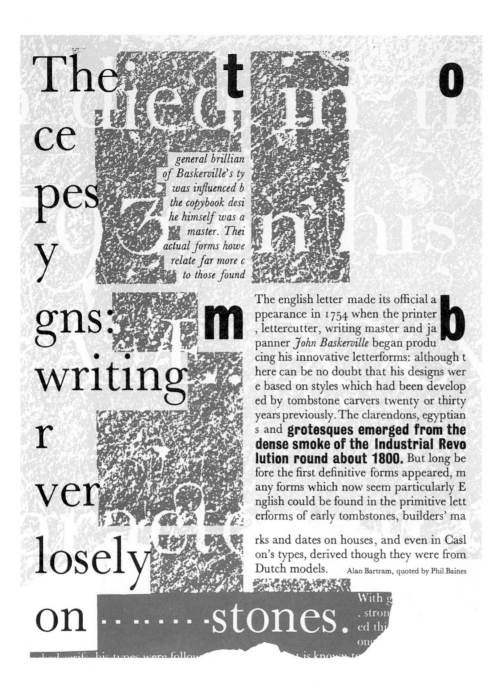

The ce pes y gns: writing r ver losely on  stones.

t o

general brillian
of Baskerville's ty
was influenced b
the copybook desi
he himself was a
master. Thei
actual forms howe
relate far more c
to those found

m

b

The english letter made its official a
ppearance in 1754 when the printer
, lettercutter, writing master and ja
panner *John Baskerville* began produ
cing his innovative letterforms: although t
here can be no doubt that his designs wer
e based on styles which had been develop
ed by tombstone carvers twenty or thirty
years previously. The clarendons, egyptian
s and **grotesques emerged from the
dense smoke of the Industrial Revo
lution round about 1800.** But long be
fore the first definitive forms appeared, m
any forms which now seem particularly E
nglish could be found in the primitive lett
erforms of early tombstones, builders' ma

rks and dates on houses, and even in Casl
on's types, derived though they were from
Dutch models.     Alan Bartram, quoted by Phil Baines

With g
. stron
ed thi
on

*Bound image.* Page from an artists' book. Spacex Gallery, UK, 1988
Design Phil Ba
ines

opposite:
Machine-generated stone-carving. UK, 1990
Design Jonathan Barnbrook

ONLY WHEN THE
TECHNOLOGY
IS INVISIBLE IS
IT OF ANY USE

TECHNOLOGY
CRAFT

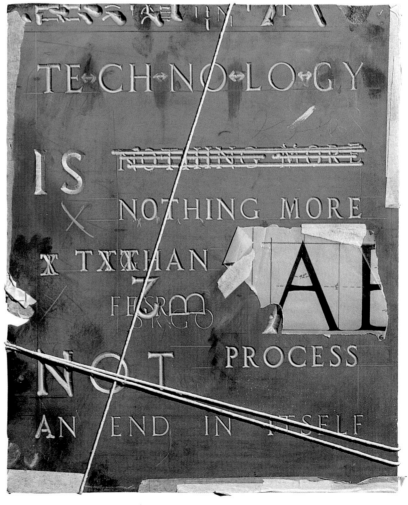

TE·CH·NO·LO·GY

IS NOTHING MORE

NOTHING MORE

THAN A

PROCESS

NOT

AN END IN ITSELF

left: Promotional poster. Ora Lighting, UK, 1991
Design Russell Warren-Fisher

below: *Next Directory 7*. Section divider. Next, UK, 1991
opposite: *Next Directory 8*. Cover. Next, UK, 1991
Design Why Not Associates

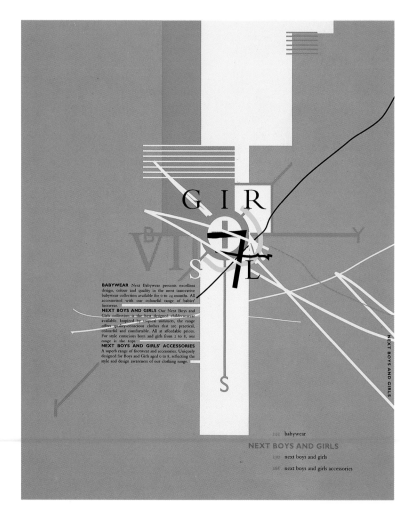

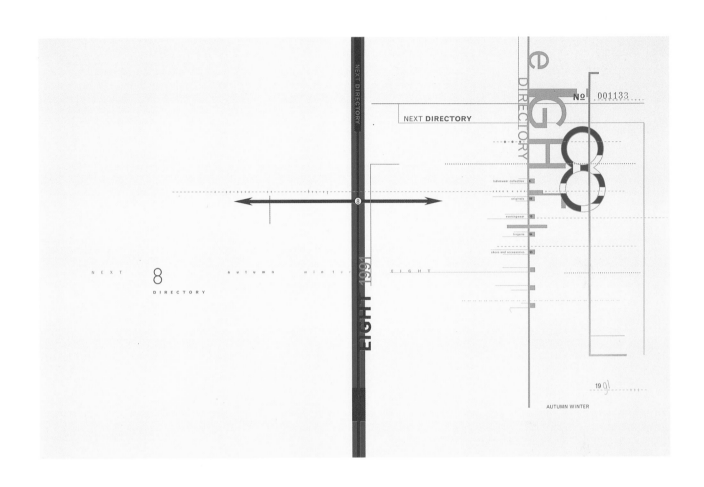

NEXT DIRECTORY

NEXT 8 autumn winter EIGHT
DIRECTORY

Nº 001133

ladieswear collection
originals
eveningwear
lingerie
shoes and accessories

AUTUMN WINTER

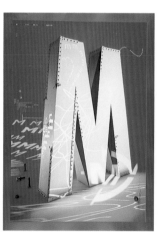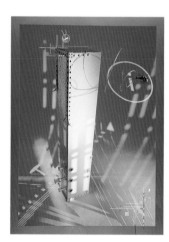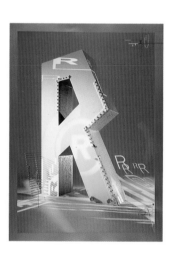

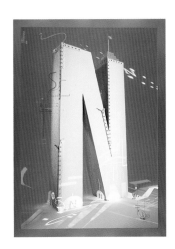
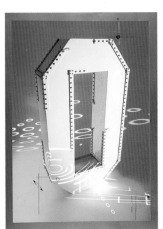
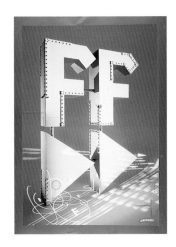

Advertising campaign posters
Smirnoff vodka, UK, 1990
Design Why Not Associates
Photography: Why Not Associates,
Rocco Redondo
Agency: Young & Rubicam

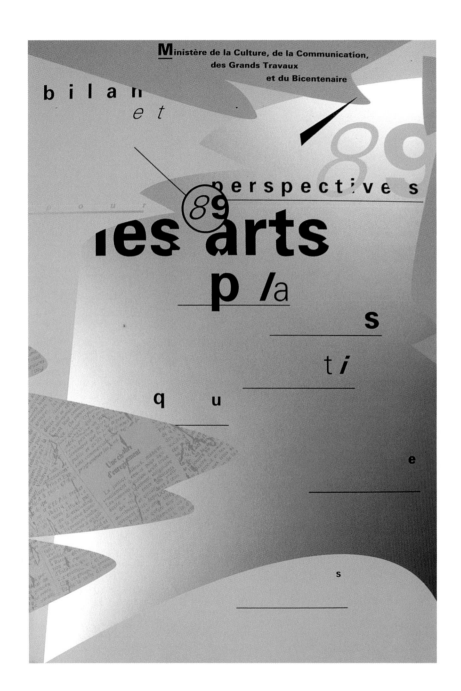

*Les arts plastiques* (The visual arts). Press kit cover. Ministry of Culture,
France, 1989. Design Philippe Apeloig

opposite:
*Tabbles of Bower*. Poster. Cranbrook Academy of Art, USA, 1991
Design Lisa Langhoff Vorhees

Jennifer Bloomer University of Florida College of
Architecture

Swanson Fund Lecture

10 December 1990 Monday 7:30 pm
CAA De Salle Auditorium

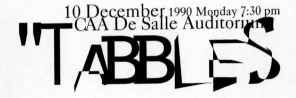

"TABBLES

O

F

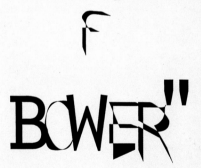

BOWER"

Cranbrook Academy of Art Bloomfield Hills
Michigan

THE MILL

showreel • title ...............................................  Video

40·41 great marlborough street london wiv ida  tel: 071 287 4041  fax: 071 287 8393

THE MILL

showreel

date ..............................................

title ..............................................

HS / Video

40·41 great marlborough street
london wiv ida
telephone 071-287 4041
fax 071-287 8393

THE MILL

showreel

date ..............................................

title ..............................................

— MATIC
high / low band

40·41 great marlborough street
london wiv ida
telephone 071-287 4041
fax 071-287 8393

— MATIC
high / low band

showreel

title ....................................................................................

......... 40·41 great marlborough street london wiv ida  tel: 071 287 4041  fax: 071 287 8393

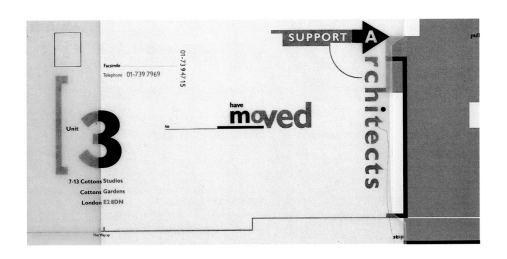

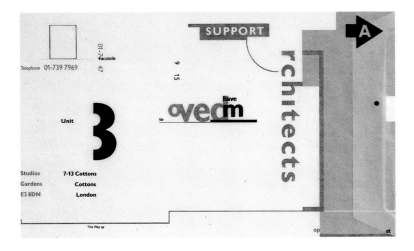

opposite:
Showreel labels. The Mill, UK, 1991
Design Siobhan Keaney

Moving card.
Support Architects, UK, 1989
Design Russell Warren-Fisher

to read message on reverse pull card to here ➝

ice

Perhaps at the beginn

time and the invisible

a seamless

twin makers of distan

wordlessne

drunk

s that eve

just before dawn

inuous.

The first light sobered

and ex

m of an ide

they spoke

of the far, the past, t

rage,

te without

give birth to ancestors

reams of reams

delineating

the distinction between

that dissipate

NING, THEIT

PLEASE, DO

#12

S

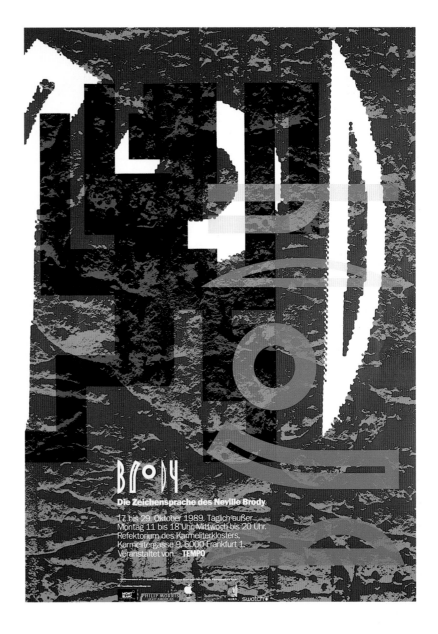

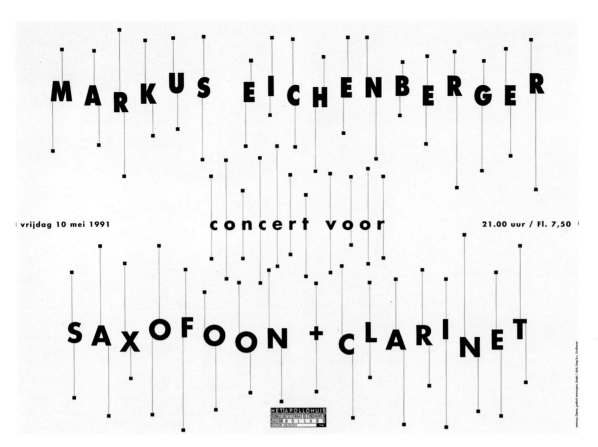

*Markus Eichenberger.* Poster
Het Apollohuis, The Netherlands, 1991
Design Tom Homburg, Kees Wagenaars Opera

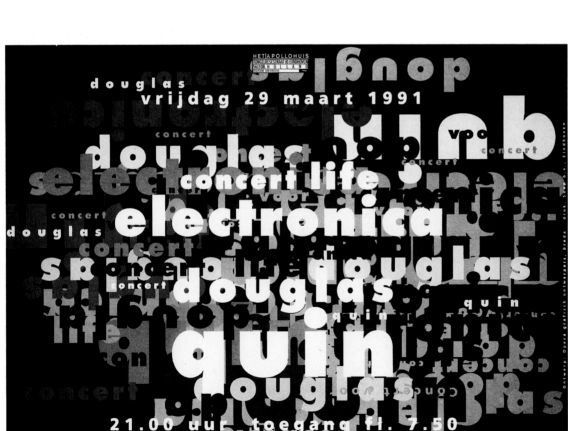

*Douglas Quin.* Poster. Het Apollohuis,
The Netherlands, 1991
Design Tom Homburg, Kees Wagenaars Opera

**Jan Boerman** electronische bandcomposities
31 oktober

**Regen** Joris Ivens; Hanns Eisler (1932) NL

8 november

**Nieuwe gronden** Joris Ivens; Hanns Eisler (1934) NL

**De 400 miljoen** Joris Ivens; Hanns Eisler (1938) USA
toelichting: Giljus van Bergeijk

**Huba de Graaff** elektro-instrumentaal Korenicken
7 november

**Entr'acte** René Clair; Erik Satie (1934)

15 november

**Ballet Mécanique** Fernand Léger; George Antheil (1924)

LIGHT

**Retour à la raison** Man Ray (1923)

**Fred Kolman** audiovisuele performance Kolman's Kube
14 november

**Anemic cinema** Marcel Duchamp (1926)

**Opus I-IV** Walter Ruttman (1921-1927)

MUSIC

**Begone dull care** Norman McLaren; Oskar Peterson (1949)

**BMB con. Justin Bennett, Roelf Toxopeus, Wikke 't Hooft** performance
21 november

**Entuziazm** Dziga Vertov (1930)

22 november

concert door Norbert Möslang en Andy Guhl bij:

**The man with the movie camera** Dziga Vertov (1929)

**Daniel Brandt** performance + toelichting You Control the Audio
28 november

**Electronische muziektechnieken bij film in de 60-er jaren**
lezing door Rick Raaijmakers

29 november

**Muziek en films van Mauricio Kagel**
lezing door Frans van Rossum

6 december

**Frank Baldé** elektro-instrumentaal
5 december 14.00uur

**De meester en de reus** Johan van der Keuken; Willem Breuker
(1980)

13 december

**De Tijd** Johan van der Keuken; Louis Andriessen (1984)
toelichting: Johan van der Keuken

**Joel Ryan** elektro-instrumentaal
5 december

FILM

**Home of the brave** Laurie Anderson (1988)

20 december

**Kiss napoleon goodbye** Babeth van Loo en Lydia Lunch (1990)

N.B. aanvangstijd 13.00uur!

**Michael Barker, Jan Boerman, Fred Kolman** Multiple Electronic Presentation
9 december

SOUND

Concerten en manifestaties in het Haags Gemeentemuseum, Stadhouderslaan 40:
toegangsprijs ƒ10, CJP ƒ7,50.

**musica electronica**

**film en muziek**

MOTION

**Michael Barker** [coördinatie] 31 oktober

**Babeth M. van Loo** [coördinatie] 8 november

docenten
**Frank Baldé** **Konrad Boehmer** **Jan Boerman**
7 november
14 november

docenten
**Gilius van Bergeijk** **Johan van der Keuken**
15 november
22 november

**Ernst Bonis** **Daniel Brandt** **Onno Mensink**
21 november

**Dick Raaijmakers** **Frans van Rossum**
29 november

**Dick Raaijmakers**
28 november

6 december

10.00 - 12.30uur en 14.00 - 16.30uur
ƒ255 toehoorders
ƒ160 museumvrienden

5 december

14.00 - 16.30uur

13 december

ƒ110 toehoorders
ƒ70 museumvrienden

20 december

12 december

19 december

De lezingen en bijbehorende concerten, installaties, etc. worden georganiseerd door
de Interfaculteit voor Beeld en Geluid van de Koninklijke Hogeschool Den Haag en Ooyevaer Desk.
Met dank aan de Gemeente Den Haag.

Plastic Labyrinth   ontwerp Allen Hori at Studio Dumbar   zeefdruk Imaba

*Laboratorium plastisch geluid* (Laboratory of plastic sound). Poster
Ooyevaer Desk, The Netherlands, 1990. Design Allen Hori Studio Dumbar

⑤ MAY / JUNE

NEW**WW**RITING @ the DETROIT INSTITUTE of ARTS

# LINES

**P**AUL AUSTER
*Series*
*National Writers*

Facing the Music (Station Hill Press)
The Invention of Solitude (Avon Books)
City of Glass (Sun & Moon Press)
Editor of The Random House Book of
Twentieth Century French Poetry

&

**R**obert **Hass**

*Field Guide* (Yale University Press)
*Praise* (Ecco Press)
*Twentieth Century Pleasures* (Ecco Press)
Co-translator of Czeslaw Milosz's
*The Separate Notebooks* (Ecco Press)

3:00 pm
Discussion:
*Poetry and Prose: Why Both?*
General Admission: $1.00
(book-signing follows
in Museum Shop

7:30 pm
Readings-Holley Room
General Admission: $3.00

**5**
**9**

*Michigan Writers Series*

**GloriaDyc**

• *Journal of a Woman
Almost thirty*
(Glass Bell Press)
• Editor of
*Moving Out:
Feminist Literary
and Arts Journal*
• Recipient of a
Hopwood Award
for fiction

3:00 p m   Reading-Holley Room
General Admission: $1.00
(book-signing follows)

**5·26**

⑫ ① ②

PRESENTO

**Lines**

*National Writers*

**6**
**6**

patricia **JONES**
*Series*

• *Mythologizing Always* (Telephone **J** Books)
3:00 PM *Informal talk:*
• Co-editor of *Ordinary Women,*
   *"The Poet Looks at Fiction"*
an anthology of New York women poets
   *Holley Room*
• Program Coordinator of
   General Admission: $1.00
The Poetry Project (New York)
   (book-signing follows)

7:30 PM *Reading—Holley Room*

General Admission: $3.00

**6·16**

*Michigan Writers Series*

**Sharon Shively**
POET AND FOUNDER OF "GORGEOUS CAFETERIA"
WITH WORK IN STRAITS AND TELEPHONE

3:00 p.m.
Reading-Holley Room
General Admission: $1.00

For Information call LINES·833·1858

The Michigan Writers Series is made possible by a grant from
the Michigan Foundation for the Arts.

The National Writers Series is funded by a grant from the
National Endowment
for the Arts.

Poetry on the Radio:
DIMENSION Sundays, 11:00 p.m. to 1:00 a.m.
CITY ARTS REVIEW Fridays, 12:00 midnight to 3:00 a.m.
both on **wdet**

end of transmission   jancourt

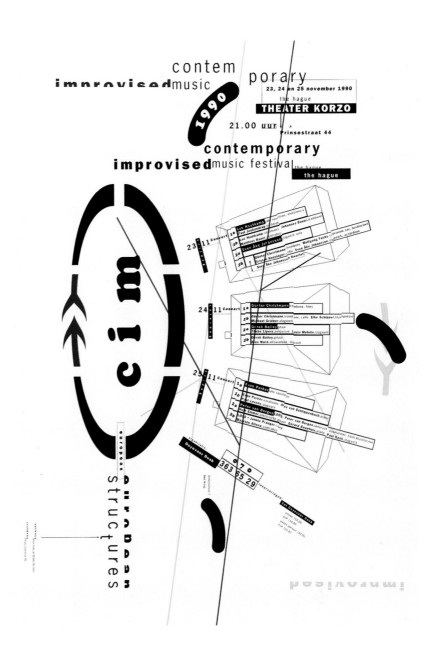

*Contemporary improvised music festival.* Poster. Ooyevaer Desk, The Netherlands, 1990
Design Allen Hori Studio Dumbar

opposite: *Lines.* Poster. Detroit Institute of Arts, USA, 1985. Design Jan Marcus Jancourt

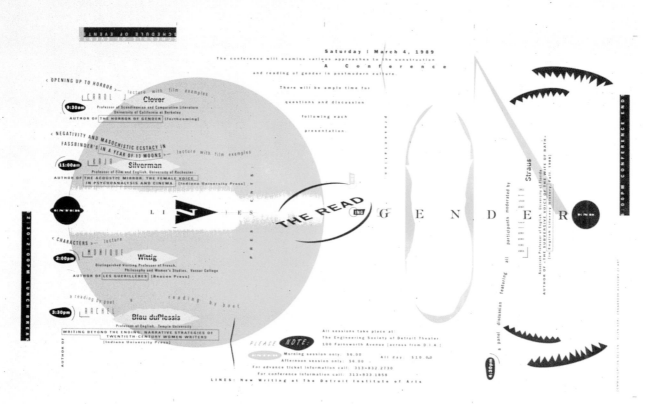

*The reading of gender.* Poster. Detroit Institute of Arts, USA, 1989

opposite:

*Typography as discourse.* Poster. American Institute of Graphic Arts Detroit, USA, 1989

Design Allen Hori

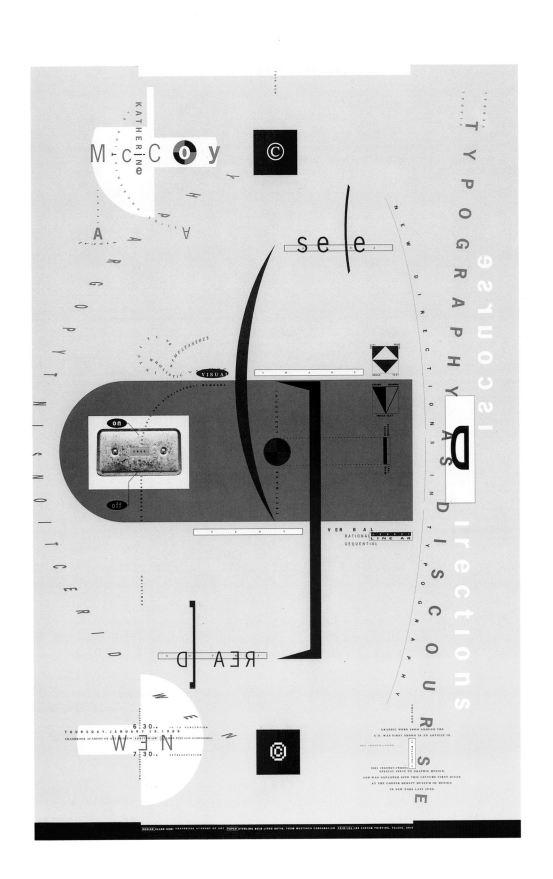

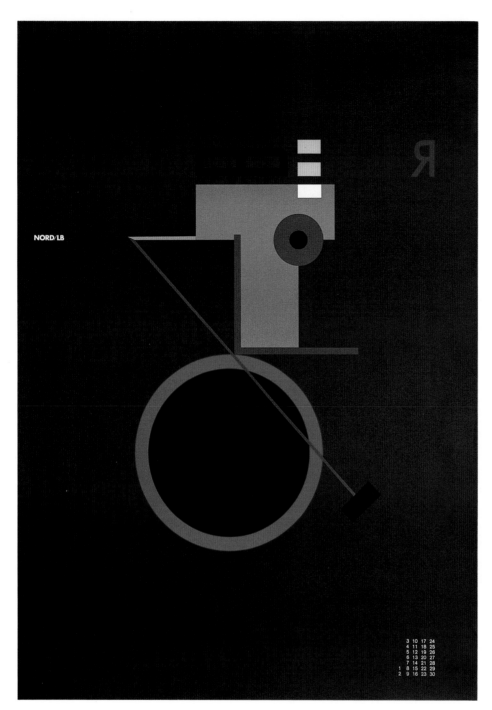

1991 calendar. Poster. Nord/LB,
Germany, 1990
Design Nicolaus Ott, Bernard Stein

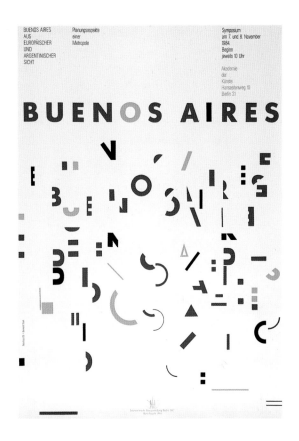

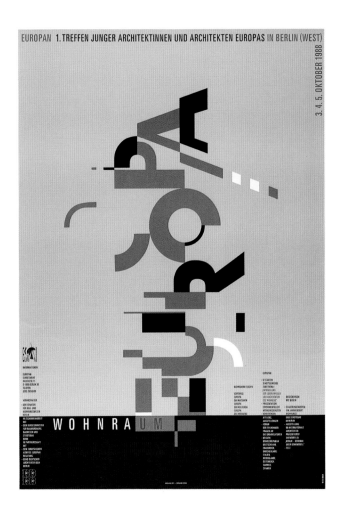

*Beunos Aires.* Symposium poster
Internationale Bauausstellung Berlin,
Germany, 1984
Design Nicolaus Ott, Bernard Stein

*Wohnraum Europa.* Poster
Berlin city council, Germany, 1988
Design Nicolaus Ott, Bernard Stein

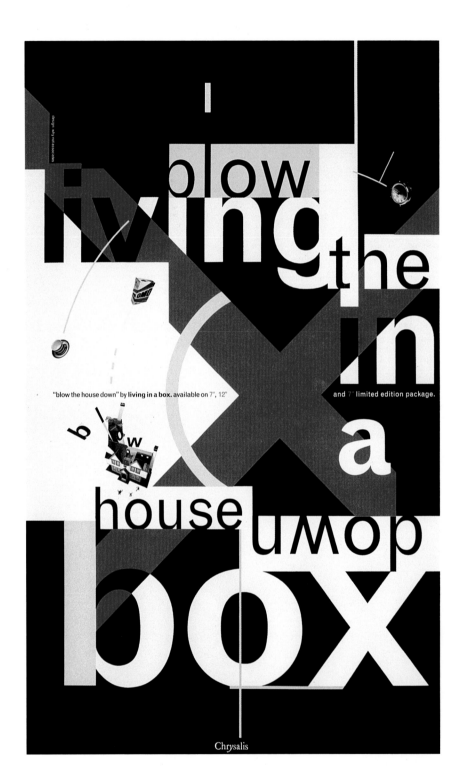

I blow living the in a house down box

"blow the house down" by **living in a box.** available on 7", 12" and 7" limited edition package.

design: why not associates

Chrysalis

opposite:

*Living in a box.* Poster
Chrysalis Records, UK, 1989
Design Why Not Associates

*Tegentonen.* Concert poster
Paradiso Amsterdam,
The Netherlands, 1987
Design Max Kisman

*Diligentia seizoen 1988-89*
(Diligentia season 1988-89)
Poster. Kunstring Dilgentia,
The Netherlands, 1988
Design Robert Nakata Studio Dumbar

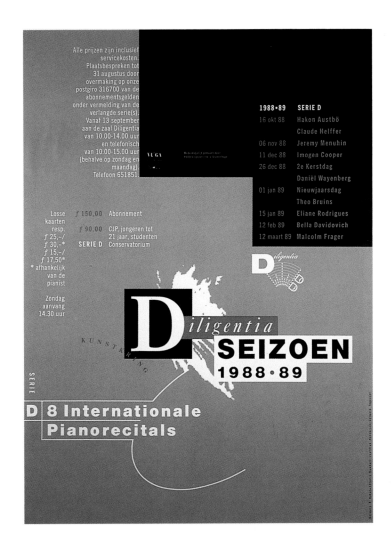

*Haçienda seven.* Club poster. Factory communications, UK, 1989. Design 8vo

Haçienda Anniversary

seven

may 20 '89
/21

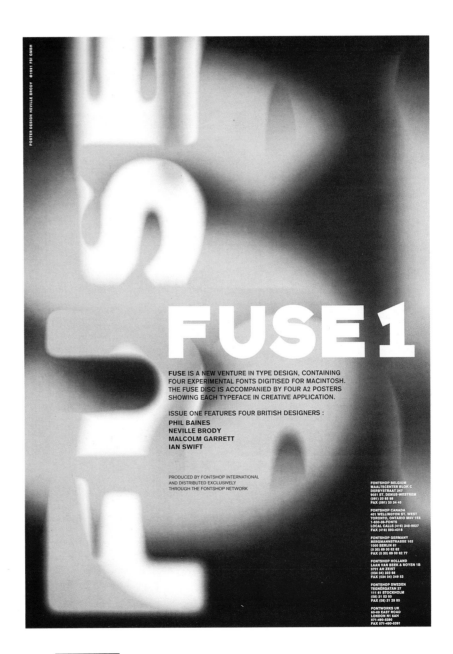

*Fuse 1*. Promotional poster. FontShop International, UK, 1991. Design Neville Brody

opposite:
Best wishes card.
Festival d'été de Seine-Maritime,
France, 1989
Design Philippe Apeloig

Poster / brochure
Jet Offset,
UK, 1991
Design 8vo

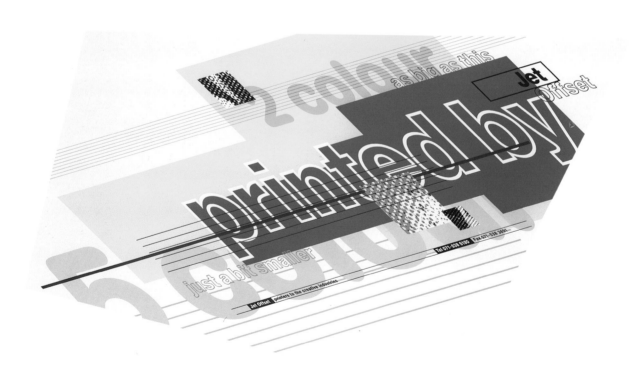

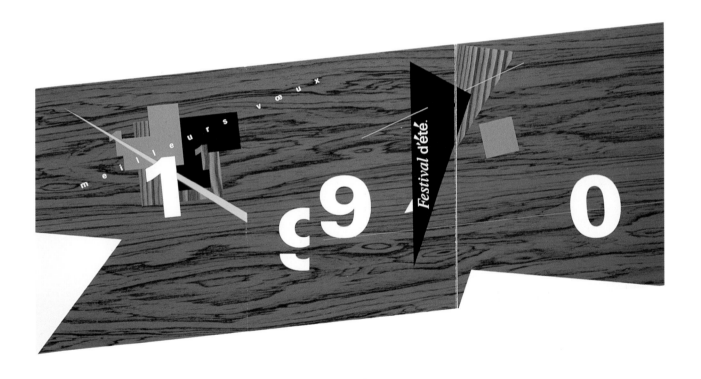

meilleurs vœux

1 ç9 Festival d'été. 0

# Haçienda Nine
## 21 May 1991
## Fac 51

8vo

above:
*Haçienda nine.* Club poster
Factory Communications,
UK, 1991
Design 8vo

*Jujol.* Exhibition poster
Spain, 1990
Design Quim Nolla

opposite:
*Tegentonen.* Concert poster
Paradiso Amsterdam,
The Netherlands, 1991
Design Max Kisman

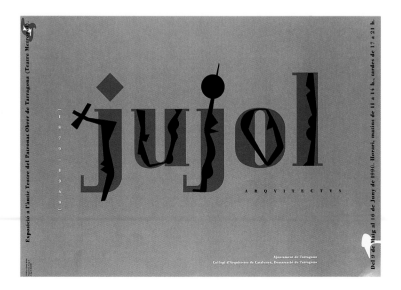

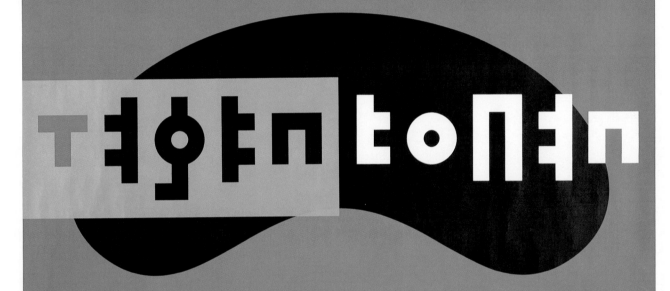

**Paradiso Amsterdam** *donderdag 21, vrijdag 22 en zaterdag 23 Februari 1991*

*Donderdag 21 Februari:* **Anette Peacock, Terminal Cheese Cake, Cop Shoot Cop, Pain Teens.** *Vrijdag 22 Februari:* **Simon Turner, Mark Springer, The Cranes, Sagar Radai, Caspar Brötzmann.** *Zaterdag 23 Februari:* **Surkus, Psychick Warriors Ov Gaia, Jackofficers, The Orb.** *Entree f12,50 & lidmaatschap per avond. Passepartout f25,- & lidmaatschap.* **Voorverkoop AUB VVV Nwe Muziekhandel Plaatwerk Get Records Boudisque RaF**

*1991*

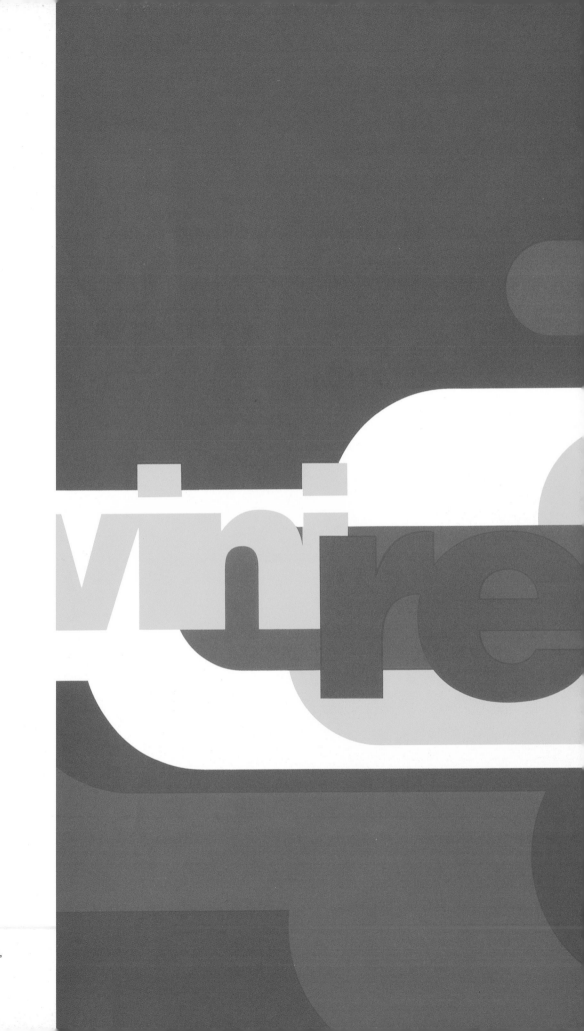

*Vini Reilly-genius*
Poster
Factory Communications,
UK, 1990
Design 8vo

the durutti column

newalbumoutnow

tv-
genius

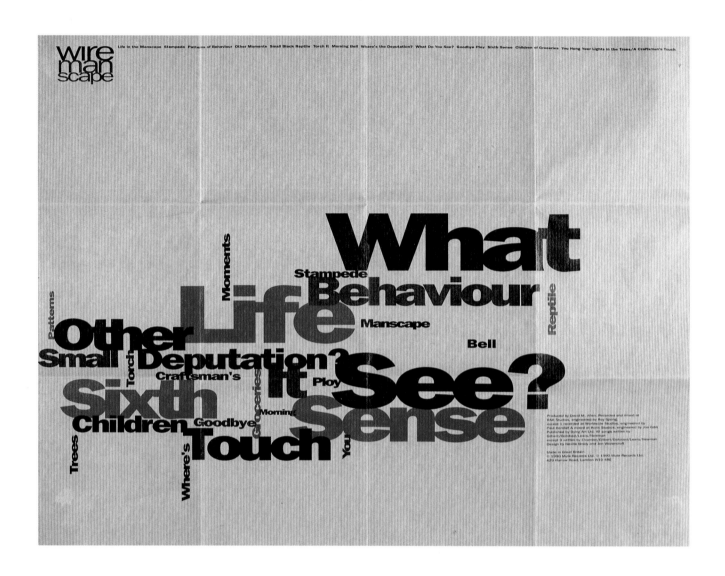

*Manscape.* CD poster (back). Mute Records, UK, 1990
Design Neville Brody  Jon Wozencroft

opposite:
*Do you read me?* Magazine cover. Emigre Graphics, USA, 1990
Design Rudy VanderLans

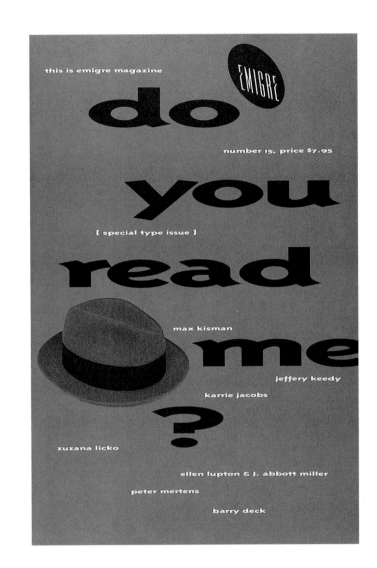

No, it's another typesetter

We're not printing a list of faces – it would take too much space and we've no doubt got what you want anyway. If you want to see them, just call for the books that not only give display and text samples for 1350 Berthold faces, but even contain useful information to enable the typographer to make considered judgements about exactly what to specify.

We have the latest Berthold equipment, the star in the typesetting firmament, and we're usually the first in the country to get the newest hardware and software. OK techno freaks, but what does that mean for the designer? Well, it means we're up to the minute technically but not to blind you with science, we understand the technics, you get the job you want – whether you like to be involved with the bits and bytes or just want the end result without knowing how we got there.

If you want to spec 10/11pt and leave the spacing up to us, that's fine, or you can spec everything in millimetres to the nearest 1/100mm and specify exact word and letter spacing to 192 unit increments. Either way, we understand what designers want. Our finely tuned aesthetics programme makes the most of any typeface – we really are talking accuracy and perfection.

We call ourselves Magic, because of the tricks we can do for you. We set type, rules, scan logos and artwork, and import images, all in position (forget your wax and scalpel).

We rotate. print-lay, distort, slant, stretch, outline

Set complete documents in position with all the text linked to the pagination. Set packaging nets in position and save master nets so you can drop in new copy as required. Then we output to film or bromide to a max image area of 300x750mm. Our film is good enough for the most exacting printer – no grey streaky blacks. And when you specify a 15% tint, that's exactly what you get – every time.

**We also have the latest headline distortion equipment (more like a typo manipulation lab). If you thought the Mac was good for effects, wait until you see what this can do.**

So what are we doing in darkest Macclesfield? Well actually, it's pretty nice here. And it means you won't be paying big city prices or dealing with big city egos. We are here to help you – we don't view our clients as an inconvenience. You can deal with people on the phone who understand your job, because they are the ones setting it! Not some remote telephone voice always looking for an excuse as to why it's late or too complicated to do. And we can get the stuff back to you fast – overnight by Datapost or courier, often same day by our own courier or Red Star (2 hours from Macclesfield to Euston). Most of our London clients proof-read laser outputs by fax first, so the bromides are right first time.

Magic Computer Graphics Co, Silk Mill, Thorp Street, Off Commercial Road, Macclesfield SK10 1LJ
Contact Granville Sellars
0625 612075

it really is magic

*It really is magic.* Promotional poster
Magic Computer Graphics Co, UK, 1990
Design 8vo

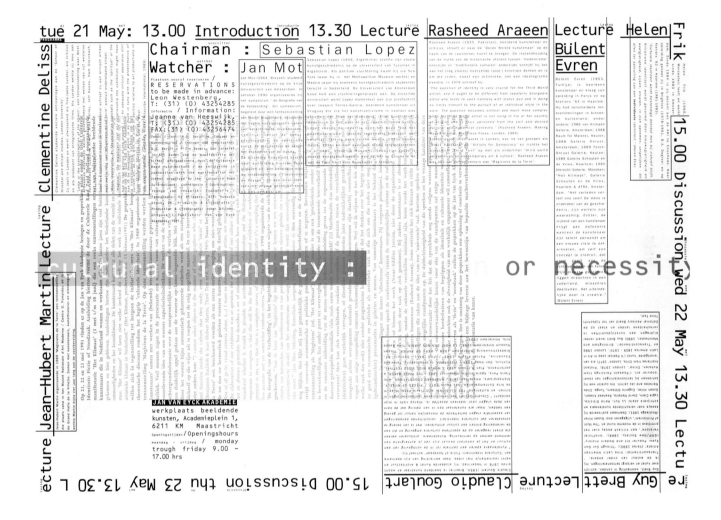

*Cultural identity: or necessity.* Symposium poster
Jan van Eyck Academy, The Netherlands, 1991
Design Ko Sliggers

e

HASH

HASH

exclamation prime HASH

HAS

ampersand

single prime (open
parentheses, close parentheses) ASTERIX****comma,
comma, comma, comma, Hyphen-Period.Solidus/
colonsemicolon ascii
circumflex Þ⅔Đ¼ffi BACKSLASH.

underscore+ascii
~~tilde~~daggerdegreecentsterling·daggerdegreecentsterlingdag
ger§·¶Eszett Diaeresis≠Æ infinity partial differential summation
p roductproductproductπππππππππ Ordfeminine
Ordmasculine OMEGA DELTA dipthong em EN EN EN em

EM em EN em EN em EN em EM; batman... & florin

OPEN DOUBLE GUILLEMOT» close double guillemot... Lozenge
–fishermans friends—fraction bar.flutter! double double

double dagger----dotless

breve ring ring ring ring DOT ACCENT single baseline quote and
double baseline quote LOGICAL NOT

( p a r e n t h e s e s
c a r e n t h e s e s )

ASTERIX****comma, comma, comma,
Hyphen-Period.Solidus/ colonsemicolon Þ⅔Đ¼ffi

CIRCUMFLEX.

b2/5⅜5/2/₵3/₹₅

BACKSLASH . ascii

underscore+ascii
circumflex
tilde~~~daggerdegreecentsterlingdagg
er§·¶Eszett Diaeresis≠Æ infinity partial differential summation
p roductproductproductπππππππππ Ordfeminine
Ordmasculine OMEGA DELTA dipthong em EN em EM em EM en
EM EN em EN em EN em EM batman... &

fl or in

# STRANGE ATTRACTORS

## SIGNS OF CHAOS

THE NEW MUSEUM OF CONTEMPORARY ART NEW YORK

## Fractured Fairy Tales, Chaotic Regimes

*Laura Trippi*

I had this phrase in my head,
"What? Is this dancing?" "What is this? Dancing?"
. . . . [T]he only thing left of *The Crucible* had to be the line
"What is this dancing?" and there had to be a dance.
—Elizabeth LeCompte

The ideas embedded in the language and images of "chaos science" strike a familiar, strangely seductive chord. Like the shapes and figures of its "fractal" geometry, our daily experience is fragmented; fraught with arbitrary juxtapositions, patterns of perception and social practice are assaulted by an onrush of information. "Reception," Walter Benjamin wrote as early as 1936, is "in a state of distraction, which is increasingly noticeable in all fields of art and is symptomatic of profound changes in apperception. . . ."[1] Faced with the demands of new computer and video technologies, we collectively confront a quantum leap in the state of distraction identified by Benjamin as a corollary of the emergence of film and photography. Leisure time, work, and art, our bodies and so also our selves — all are absorbed into the breathing and buzzing surreality of simulation culture, of global information networks and cybernetic machines.

"Chaos science" is an umbrella term for two related and emerging fields: fractal geometry and the study of complex dynamical systems. If its computer-generated video graphics strike in us a sympathetic chord — images of a randomized geometry and systems in chaotic states — perhaps it is because of our immer-

sion in an atmosphere turbulent with new technologies. The guiding myths and models of modernity have been hopelessly infiltrated and frayed, and even the once invigorating concept of "crisis" itself seems to have collapsed. This is a journey into space — the "phase space" of turbulence and "sensitive dependence"; of "multidimensional degrees of freedom"; of the decay, creation, and random fluctuation of information. It began as an experiment, a gamble, an *essay* in the sense of an attempt or try, a search for the strangely fractured fairy tales of an emerging regime.

### *Border Regions*

Benoit Mandelbrot's compendium and guidebook, *The Fractal Geometry of Nature*, was published in 1983. In 1985, Goethe House New York sponsored the first exhibition of fractal graphics, produced by scientists and offered in unaltered photo-reproductions as art.[2] By the mid-eighties, the shapes and formulas of fractal geometry had begun to appear in the work of practicing artists. But forces other than the discourse of science seem to have prepared the ground for the expropriation of its latest images and ideas.

The term "fractal," a variant of "fractional," points to the idea both of fragmentation and irregularity. An emerging branch of geometry, the study of fractals breaks with the Euclidean tradition of idealized forms. With an infinite nesting of pattern within pattern, repeating across scales, fractal images open onto an area devoid of fixed coordinates. Because the mathematical operations that produce fractal "landscapes" depend on the introduction of chance (random number generation), each repetition of a given pattern asserts a fractional difference from all others. The notion of boundary, too, is confounded. On closer look, the line dividing two regions reveals unexpected complexity. In the literature, this is sometimes expressed as the

---

*Strange attractors: signs of chaos*
Exhibition catalogue: cover and pages
The New Museum of Contemporary Art, USA, 1989
Design Marlene McCarty, Tibor Kalman M&Co

---

> JAMES WELLING. I was trying to work beyond visibility, with notions of sense, sensuality, that which is of the senses.... I was engaged with other topics of which legibility, or representation, always plays a part: hallucinations, extreme mental states, the drawings of psychotics–castles of detail, sensual, non-quotidian, non-representaional. There were ideas about the wild, wilderness, nature, geological formations. Fabulous landscapes. Creating things that involve aspects of fiction or science fiction.

When I was working on the Aluminum Foil photographs, I understood that I was creating a program or a machine to manufacture randomness, a system to make random images. It seemed extremely simple, straightforward, and *economical*, and also yielded all these images. This one piece of metal could be constantly refolded into itself. It was both a physical way to make pictures, and an analogy for other things, like language: the way language uses the same words but is constantly repermuted and reconfigured.

**WERE YOU AFTER A TENSION**
James Welling
**BETWEEN**
Interviewed by
**LEGIBILITY AND ILLEGIBILITY**
Laura Trippi
**IN THESE PHOTOGRAPHS?**

> LAURA TRIPPI. I just read a brief essay David Joselit wrote for your show in Vienna, which discusses your recent photographs of buildings by the late 19th-century architect H.H. Richardson. Joselit cites Richardson's aim as that of "disciplining the picturesque." The phrase caught my attention in connection with your Aluminum Foil photographs and the way they sort of traffic in the picturesque or sublime.

> JW. I don't think we have feelings of the sublime anymore. It's a historical idea. I think these photographs do evoke a *lost* feeling of the sublime. The sublime I'm interested in is not a landscape, but more like snow on a T.V. screen. It has its own kind of beauty—if you can apply the word "beauty" to it. We're putting 19th-

century terms with a mid-20th-century electronic landscape.... But the idea of electronic snow, of raw electronic states, it was a pretty powerful idea. I don't think I've ever really talked about coming out of making video tapes and going into photography. But that was one of the reasons that, when I figured out what I wanted to do with the photograph, I worked the way I worked in the video studio, on a table top, with a tripod, etc.

986-7, James ...ling produced a ...es of "circle ...intings" that ...ear a striking ...esemblance to the "sphere ...tremas" of Mandelbrot, among the least obviously "fractional" of fractal images, printed in black-and-white in the book (*The Fractal Geometry of Nature*). In Welling's paintings, the massing shapes come across at once as vaguely ominous and profoundly pop, suggestive in this context of a deadpan commentary on the "promiscuity" of fractal graphics (even, more generally, on that ...f simulation),the ...ar-contagion of ...ir allure.

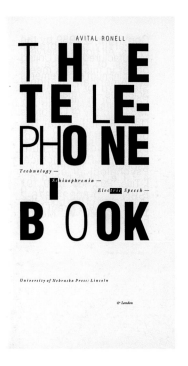

*The telephone book*
Title page and book pages
University of Nebraska Press,
USA, 1989
Design Richard Eckersley

between two rooms, Bell's voice was vibrating from it, shouting "Ahoy! Ahoy!" "Are you there?" "Do you hear me?"—what's the matter?" . . . Then began the first "long distance" telephone conversation the world has ever known. We recorded it word for word. The croakers made us do that. The common attitude toward any new thing is apt to be pessimistic for the average man thinks that what hasn't been done, can't be done. It was so with the telephone. It seemed a toy to most persons. Some of Bell's friends, although they had heard the thing talk at the laboratory were doubtful as to its practical value, and one of them of a scientific turn of mind told me that he didn't see how the telephone could be accurate enough for practical use for every spoken word has many delicate vibrations to be converted into electrical waves by the telephone and if some of them get lost the message cannot be intelligible. (A, 94–95).

The first long-distance electric conversation enveloped language in high-decibel noise; [several lines of this paragraph are typographically distorted and partly illegible] ... as a noise machine is generated solely on good vibes. Ever since Watson had known Bell, he recounts, his habit of celebrating successful experiments by what he called a war dance was respected, and "I had got so expert at it that I could do it as well as he could. That night, when he got back to the laboratory, we forgot there were other people in the house and had a rejoicing that nearly resulted in a catastrophe" (A, 95–96).

The morning after: "after a sleepless night, as I started down the stairs to go to Williams' to build some more telephones, I saw our landlady waiting for me at her door with an acid expression on her face" (A, 96). The waiting woman at the end of the line, imaged in the liquefying anger of experimental elements, her acid face about to shape words. The naughty young man: "My conscience was troubling me and I felt something disagreeable was about to happen. My pretense of great haste did not work for she stopped me and said in an unpleasant voice, 'I don't know what you fellows are doing up in the attic but if you don't stop making so much noise nights and keeping my lodgers awake, you'll have to quit them rooms.' I couldn't say much to calm her. I assured her we would be more careful although for the life of me I didn't see how we could get along with any less noise than we had been making. I couldn't blame her

finding fault. She wasn't at all scientific in her tastes and we were not prompt with our rent" (A, 96). This is the only time Watson invokes the prerogatives of scientific sensibility, in the key of aesthetical taste, and we would not be wrong to suggest that he spits out the signifier with irony. The noise without which they would not be able to get along presumably resulted from the war dancing, as telephone connection were tried out in other spaces. Yet the inevitability—at however long a distance—of noise as a by-product of this innovation in the speech conveyance has just been announced to the landlady, whose figure is firmly planted to the ground. This may be the birth of

a new noise era

whose contours make Kafka's thin text,

"The Neighbor,"

explode.

The telephone was hardly a beloved or universally celebrated little monster. It inspired fear, playing on fresh forms of anxiety which were to be part of a new package deal of the invisible. This hardly replicates the way Watson puts it, yet he gives abundantly profiled clues to follow. It soon becomes clear that schizophrenia recognizes the telephone as its own, appropriating it as a microphone for the singular emission of its pain. Schizophrenia was magnetized by the telephone the way neurosis rapped on Freud's door. In a fundamental sense, we can say that the first outside call the telephone makes is to schizophrenia—a condition never wholly disconnected from the ever-doubling thing. Watson mounts his case slowly, describing the call of aberrancy first in terms of "embarrassment." Men in particular were uneasy about the thing. For instance: "It also interested me to see how many people were embarrassed when they used the telephone for the first time. One day a prominent lawyer tried the instruments with me. When he heard my voice in the telephone making some simple remark he could only answer after a long embarrassed pause, 'Rig a jig, and away we go'" (A, 98). Regression takes hold, the call transfers the speaker to a partial object, a false self caught up in the entanglement of fort/da: away we go.

Watson defines essentially two kinds of men that visited the telephone. The first we have just listened to, away he went. The second returns us to a recurrent concern, the consummate knowledge of disconnection that connects the schizophrenic to things and machinery: "Men of quite another stamp from those I have mentioned occasionally" (A, 98). Though he is not necessarily

---

"God's Electric Clerk"

[The right-hand page text is heavily over-printed and typographically distorted, rendering it largely illegible.]

# The BAUHAUS mistook legibility for communication, (it's a man's world).

Nicolette Gray: in 1 p.12 'It is not really necessary for the beholder to read, or understand these words. THE WORDS ARE PART OF THE MEDIUM ; what the artist is communicating through the medium is his reaction to, his understanding of these words, which he h as expressed in the way they are inscribed.'

**Six sheets**, as if fragments, (keys to a la rger argument/point of view: wider te rms of reference lead to a better, more fully human typography), **in order:-**

1,2,3,4:

LEFT  RIGHT

FORGET  REMEMBER

SIGHT  SOUND

PRINT  MANUSCRIPT

INTO THE HOT...

'The system was basically very simple. T he stationer h eld **a copy of the book** (exe mplar) **unbou nd in** quires o r **pieces** (peci e), and hired i t out to a scri be piece by pi ece to copy.'

Richard Hunt: in 2 p. 202

James S utton an d Alan B artram: i n 3 p.26

'The Aldine Ro man is the arche type of all Old Face types whic h during the six teenth century e stablished their ascendancy ove r gothic throug hout Europe.'

'**Grotesques** , which **are cl oser** in some ways **to the b lack letter t han the nor mal roman**.'

John Le wis: in 4 p.46

*The Bauhaus mistook legibility for communicatio n*. Cover and page from college thesis, UK, 1985
Design **Phil Baines**

# INTO THE HOT…

Ludwig Grote: i n 9 p.18

'PROPORTION WAS TO TAKE THE PLACE OF . FORM
hy twice the n ver; discredited. **Broader terms** 'All fashion i
SYNTHESIS TO REPLACE. . . . ANALYSIS
umber of sym **of reference offer more possi** s filched off f
LOGICAL CONSTRUCTION . LYRICAL SUSPENSION
bols, if half th **bilities for finding a rich chaos** aggots- then,
MECHANICS . CRAFTSMANSHIP
e number acco **,** subtle differences, (unity in vari two or more y
COLLECTIVISM . INDIVIDUALISM
mplishes the s ety), **an appeal to more of our b** ears later…'
SUCH WERE THE DEMANDS OF DE STIJL.'
ame thing?' **eing** and an affirmation of our tr 'Rational ,

Mark E. Smith: o n 28

Herbert B. Oliver : in 29

'The old ind ue potential and wealth. **Broade** objectiv
ustrialism **r terms of reference as somet** e thinking ca
was unconcern **hing to work from,** whatever th n produce be
ed with soul or e goal- legibility, clarity or a rich, l autiful art, b
spirit: it produc ayered variety- **give typograph** oth fine and a
ed but for mon **y its real kick,** its real utility or it pplied. **What**
ey, colourless g s real wonder, and **it was broad** I find depres

Ivan Illic h: in 21 p. 13

'**Institutions** create certainties, and taken seriously, certainties
oods that echo **er terms of reference that BA** sing is the ex
**deaden the heart and shackle the imagination.'**
ed the charact **UHAUS codification stifled.** tent to whic
eristics of any **B**AUHAUS typography came t h this approa
nation but our o assume as many gratuitous ch is misappl
own. We cease aesthetics as the work it reacted ied. In my vie
ed to be. The s against, and the original aims we w the best gr
hekels buried u re soon lost. **Bauhaus disciples** aphic design
s. Our faith is g **ignored many of the questio** comes from p
one in all that & **ns posed, scraped at, or ans** eople trained
we are like a sk **wered on these six sheets; the** in other areas
eleton leaf-plan **y lacked** the **real pioneer spirit** - notably pain
ts pressed in a b **and zest** of El-Lissitsky, Alexand ting and print
ook.' er Rodchenko, Kurt Schwitters or making.'
Piet Zwart; **the cheek** of Dada; **t**
**he heat** of Hendrik Werkma
n; the **rational historic**
**ism** of Eric Gill **and**
the **grace** of A
nthony Fr
oshau
g.

# lan gua ge|b

SA
''Bridal Bits''
**salt** **sel** **salz**

**50**

T H O N

s p e c i a l f i l t r e

:

:

(weave -on)

D Share
jucy
mini

4  1  1  8

*s*        *e*   *l*        *e*  *c*              *t*

Mr. Juicy ( **Steve.** Hu bba Bubb

A dream come true
for 50p
wet & dry
whole cold
wet & wavy

(weave
-on)

sta - sof - fro
ultra sheen afro
sheen
Fantasyclub

**16 Ears p** **ierced**
**& 12 tun** **es**
**bankrup** **t**

18 x 12 x 18

(we

19 x 21 x

Ste
*Star*

Terry's

*T*  **HE**
*P*  **ANTRY**
    **PEN**

• • • • • • • •

words: david blamey. design: phil baines.

# rea ks|h ere

*Fresh*

## ave- on)

the critic

ice

's cho

**V**$_T$ **Ne** ck

super

"

"

"

"

,

Va-Boy
*90p. a pot*

**Big**

**gulf**

(T
D)

**op**

**eck**

wise
182
Yes,
we do!

**.....&**

**"99"**

**knives**

| Lo | | Sunny shoes |
| M | ▦ | wide approx |
| T | ☐ | any case |
| P | ▦ | Gary angels |
| E | ▦ | Sir  sir  sir |
| ut | | No eels today |

*e*          *d*

**[s**

**a.** Elvis Pr esley; Sam Fox; **Jesu**

publisher: billionth press, 1988. edition, 2000

133

Is there really a If there is, it coul d be just a fashion swing. After a sea son of th romantic brushstrokes a nd crayon effects, some e ar thin g more high-tech m rang ay b e in the air: a multi-l eme ayere d look of hard type on (. nt o ....) vi new enthusiasm fo r typography amo ng designers? deo textures. But what exactly is typography? f co mpo sed t ype.

*Graphics World*. Magazine cover illustration. Graphics World Publications, UK, 1989. Design Phil Baines

*Octavo.* Magazine pages. 8vo, UK, 1990 Design `8vo`

Bridget Wilkins

## Type and Image

140 275 · 180 353

**Is it possible**

although the actual letterpress machinery
is now part of the museums

**Why
the centred
layout?**

grid grilled Gill

**Type as image alone is meaningless unless
it has an inherent interrelationship to the
information it is communicating, otherwise
it can only be decoration.**

**What a con.**

143 275  Its origin is in the book format. What is the relevance today? The relevance is that it is easy, it's a convention, it's a tradition that is being adhered to as a safe and sure formula, its logic and reasons forgotten; a strait-jacket without any questioning. The new Design Museum, whose designers say 'Shopping is a leisure activity just as much as museum going, and it has to be seen in the same light'. → 143 204

143 275  Type as printed words have a respectability and authority that the handwritten word does not have due to its historical development undertaken by Gutenberg. The Design Centre, London, states 'design is the vital extra ingredient which is helping successful companies to achieve their specific objectives in print'. → 172 312

147 275  Obviously type and image can only really be talked about after the advent of type. Type as a term implies a particular process. But the early typeset page was aiming to ape the handwritten era. Nevertheless the hand-done manuscript page was conceived as a whole. Image was an integral part of the page and the letters. Speedreading → 181 302

162 275  The proliferation and saturation of the High Street with decorative type and image of the retail genre is no excuse for this to be exacerbated and repeated in print. In Britain we are locked into a cultural island, indulging in the false security of the misinterpretations of our visual and industrial design heritage. The letterpress process facilitated print, but at the same time established particular visual conventions of structure like grids and columns. These are still adhered to in most uses of type and image, be it a National Gallery catalogue or *Design Week*. → 180 206

160 202  To refer to 'type and image' in the same space, breath, sentence or page is a meaningful way today? Both 'type' and 'image', by definition should communicate a visual message, and are only valid when the two are as one, in harmony, empathy and together, related in context and use visually. Thatcher's high profile 'design' does not encourage or support this definition. It promotes and syncours type as decoration, image as decoration, type and image as decoration, divorced from and devoid of any sensitivity to enhancing, let alone reflecting, the message. The message → 160 313

160 202  Words and images are pummelled and pushed into arbitrary preconceived formulae. This nostalgic visual strait-jacket makes a mockery of the meaning and communication of the message. It makes type and image apart. Typographics do not read but they decorate and illustrate pages. → 160 329

161 302  was made possible by standard

163 202  pulverised and dehydrated out of existence on the page. From children in school have today are not taught the visual sensitivity to letters as they are in the East or even in Alfred Fairbank's days. Our passive environment requires instant results. Instant gardens, with container load mature plant from the garden centre; instant refined fast food; the instant blend formula for type and image. Let meat in the past, and now the Mac have enabled instant print, but print at what cost? → 160 347

147 344  So why did the editors choose type and image as the theme for this issue? Well, the answer lies in → 170 342

160 205  With illuminated capitals the image become part of the letters and words. In medieval times visual literacy was strong; and image were meaningless without each other on the page, written as letters or pictures. Often use was indicated by the visual relationship of words and image - bibles on display in church were visually different from books to be read alone. Use was communicated visually. → 140 315

172 297  Education has encouraged the use of decoration with type as image. We have the whole gamut of mixtures. The kids colouring-in book, filling preconceived shapes with colours, patterns, type and images, or fast food processed → 162 315

176 352  or that a house should have a door?. Well, sadly this still applies today, so that speedreading is seen as a desirable skill; ignoring the visual communication of type and image. → 140 333

176 313  Legible is easy to read. If it is easy to read it bypasses the visual potential of the message. People prefer the comfort of legibility. The passive, comfortable approach and negative visual interrelationships of type and image were firmly rooted by Stanley Morison in the perpetuation of legibility and the cultural backwater of → 140 347

173 336  This does not have communication as its main thrust; or words, or type and image - but design, like designer jeans, like → 141 351

135

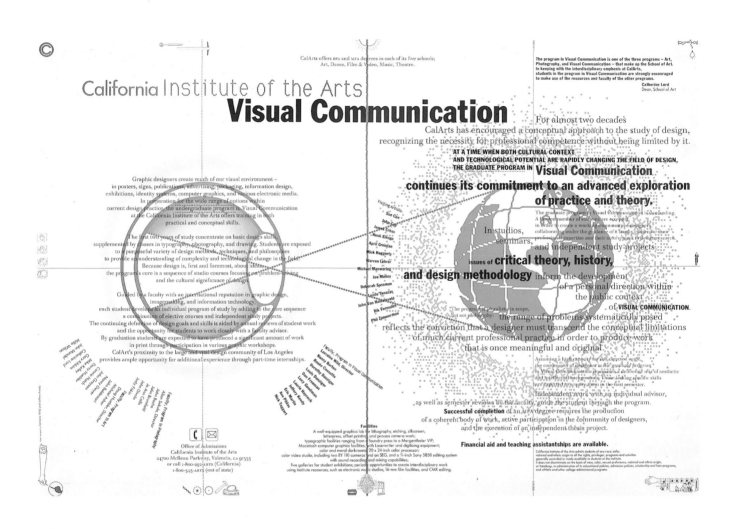

*Visual communication*. Faculty poster
California Institute of the Arts, USA, 1986
Design Jeffery Keedy, Lorraine Wild

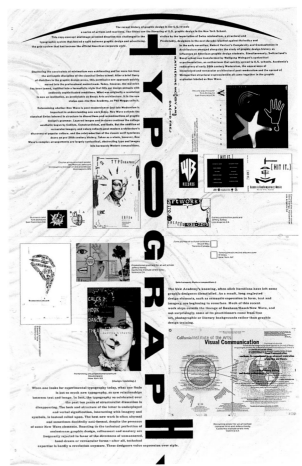

*ID* "Graphic design" issue. Magazine pages
Design Publications, USA, 1988
Design David Frej

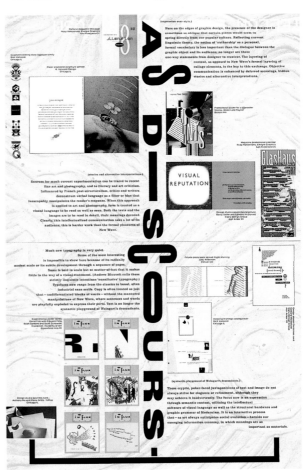

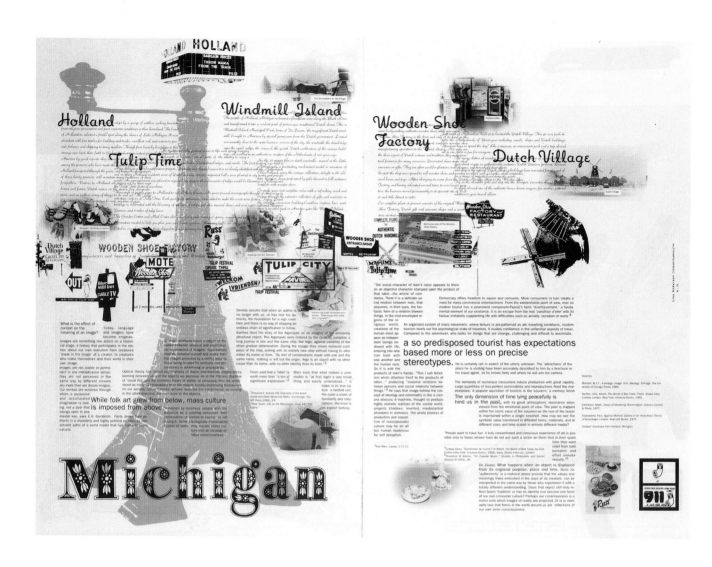

*Emigre.* Magazine pages
Emigre Graphics, USA, 1988
Design Lisa Anderson
Cranbrook Academy of Art

K A T H E R I N E **mcCoy**
M I C H A E L **mcCoy**

Aʀᴛ **science**

Nothing pulls you into the territory between art and science quite so quickly as design. It is the borderline where contradictions and tensions exist between the quantifiable and the poetic. It is the field between desire and necessity. Designers thrive in those conditions, moving between land and water. A typical critique at Cranbrook can easily move in a matter of minutes between

Mᴀᴛʜᴇᴍᴀᴛɪᴄ **poetic**

a discussion of the object as a validation of being to the precise mechanical proposal for actuating the object. The discussion moves from Heidegger to the "strange material of the week" or from Lyotard to printing technologies without missing a beat. The free flow of ideas, and the leaps from the technical to the mythical. stem from the attempt to maintain a studio plat- form that supports each student's search to

Dᴇsɪʀᴇ **necessity**

find his or her own voice as a designer. The studio is a hothouse that enables students and faculty to encounter their own visions of the world and act on them — a process that is at times chaotic, conflicting, and occasionally inspiring.

Watching the process of students absorbing new ideas and in- fluences, and the incredible range of in- terpretations of those ideas into design, is

Mʏᴛʜᴏʟᴏɢʏ **technology**

an annual experience that is always amaz- ing. In recent years, for example, the de-

**discourse**

partment has had the experience of watching wood craftsmen metamorphose into high technologists, and graphic designers into software humanists. Yet it all seems consistent. They are bringing a very per- sonal vision to an area that desperately needs it. The messiness of human experi-

Pᴜʀɪsᴛ **pluralist**

ence is warming up the cold precision of technology to make it livable, and lived in.

Unlike the Bauhaus, Cranbrook never embraced a singular teaching method or philosophy, other than Saarinen's exhortation to each student to find his or her own way, in the company of other artists and designers who were en- gaged in the same search. The energy at Cranbrook seems to come from the fact of

Iɴᴅɪᴠɪᴅᴜᴀʟ **communal**

the mutual search, although not the mutual conclusion. If design is about life, why shouldn't it have all the complexity, vari- ety, contradiction, and sublimity of life?

Much of the work done at Cranbrook has been dedicated to changing the status quo. It is polemical, calculated to ruffle designers' feathers. And

Dᴀɴɢᴇʀᴏᴜs **rigorous**

*Cranbrook design: the new discourse*
Book page. Rizzoli, USA, 1990
Design Katherine McCoy
P. Scott Makela, Mary Lou Kroh

**Bill Rauhauser**

**Born:** August 14, 1918   Detroit, Michigan

**Education:** Bachelor Degree, Architecture . . . University of Detroit, 1943

**Employment:** Professor of Photography, Center for Creative Studies —
College of Art and Design, 1970 to present
Visiting Lecturer at University of Michigan, Ann Arbor
1975-76, History of Photography

**One Man Exhibitions:**
*Pierce Street Gallery*, Birmingham, Michigan 1982 and 1986
*Edwynn Houk Gallery*, Chicago, Illinois, 1981
*Sara Reynolds Gallery*, University of New Mexico, 1978
*South Bend Art Center*, Indiana, 1966

**Selected Exhbitions:**
*Pierce Street Gallery*, Birmingham, Michigan, 1983, 1985, 1986
*Saginaw Art Gallery*, Saginaw, Michigan, 1985
*Pontiac Art Gallery*, Pontiac, Michigan, 1985
*Detroit Institute of Arts*, Detroit, Michigan, 1977, 1983, 1984
*Halsted Gallery*, Birmingham, Michigan, 1972, 1974, 1982, 1983
*The Mill Gallery*, Milford, Michigan, 1981
*Exhibition for Michigan Artists*, Detroit, Michigan, yearly 1944 through 1958
*Birmingham Art Center*, Birmingham, Michigan, 1965, 1973
*Museum of Modern Art*, New York, New York, Family of Man Exhibition 1954

**Professional Activities:**
Numerous Lectures
Workshops

**Work in Collections:**
*Detroit Institute of Arts*, Detroit, Michigan
*Kresge Foundation*, Troy, Michigan
*Florence Crittenten Hospital*, Troy, Michigan
*Walter Rosenblum*, New York, New York
*David Rottenberg*, Chicago, Illinois.
*Warren Covell*, Bloomfield Hills, Michigan
*Morris Baker*, Bloomfield Hills, Michigan

**Listed In:** Archives of American Art

W hile most of his work derives from the "straight," or, documentary, tradition of photography, Bill Rauhauser has also explored the more manipulative possibilities of the medium. The resulting images have most frequently taken the form of collage.

Rauhauser is a formalist who defines works of art as ". . . primary objects and not cultural by-products or spin-offs of reality." While he believes that the creative element lies in both conception and execution of the work, Rauhauser's recent photographs manifest his increasing interest in aesthetic quality. "More and more," he states, "I am coming to believe that something to be looked at should be attractive."

In this series, the artist restructures each image. The resulting ambiguity invites speculation beyond a mere reading of the facts presented.

**Mary McNichols**
*Professor of Art History*
*Center for Creative Studies*

**Checklist of the Exhibition**      **Number, Title, Year, Size, Medium.**

| No. | Title | | | |
|---|---|---|---|---|
| 1. | *Restructured photographs*, 1985, 14½"x12" | Silverprint |
| 2. | *Restructured photographs*, 1985, 14½"x12" | Silverprint |
| 3. | *Restructured photographs*, 1985, 14½"x12" | Silverprint |
| 4. | *Restructured photographs*, 1985, 14½"x12" | Silverprint |
| 5. | *Restructured photographs*, 1985, 14½"x12" | Silverprint |
| 6. | *Restructured photographs*, 1985, 14½"x12" | Silverprint |
| 7. | *Restructured photographs*, 1985, 14½"x12" | Silverprint |
| 8. | *Restructured photographs*, 1985, 14½"x12" | Silverprint |
| 9. | *Restructured photographs*, 1985, 14½"x12" | Silverprint |
| 10. | *Restructured photographs*, 1985, 14½"x12" | Silverprint |
| 11. | *Restructured photographs*, 1985, 14½"x12" | Silverprint |
| 12. | *Restructured photographs*, 1985, 14½"x12" | Silverprint |
| 13. | *Restructured photographs*, 1985, 13"x26" | Silverprint |
| 1. | *Still Life*, 1986, 14½"x18½" | Silverprint |
| 2. | *Still Life*, 1986, 14½"x18½" | Silverprint |
| 3. | *Still Life*, 1986, 14½"x18½" | Silverprint |
| 4. | *Still Life*, 1986, 14½"x18½" | Silverprint |
| 5. | *Still Life*, 1986, 14½"x18½" | Silverprint |

**Statement**

**Bill Rauhauser**

In the "Restructured Series" I have attempted to de-emphasize the importance of photographic seeing and reduce the transient element. Selection of subject matter is based not on what it is but rather on what it might become. The shift is from statement to suggestion.

*The market presents Phillip Fike,*
*Bill Rauhauser.* Exhibition catalogue
Detroit Artists Market, USA, 1987
Design Edward Fella

Book pages. Coop Himmelblau, Germany, 1989
Design Friedhelm Grabowski
Hochschule für Gestaltung
Offenbach

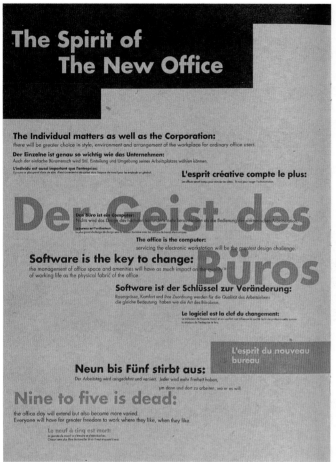

# The Spirit of The New Office

**The Individual matters as well as the Corporation:**
there will be greater choice in style, environment and arrangement of the workplace for ordinary office users.

**Der Einzelne ist genau so wichtig wie das Unternehmen:**
Auch der einfache Büromensch wird Stil, Einteilung und Umgebung seines Arbeitsplatzes wählen können.

**L'individu est aussi important que l'entreprise:**
Il y aura un plus grand choix de style, d'environnement et de confort dans l'espace de travail pour les employés en général.

**L'esprit créative compte le plus:**
Les offices seront conçus pour stimuler les idées. Et non pour ranger l'administration.

## Der Geist des Büros von morgen:

**Das Büro ist ein Computer:**
Nichts wird das Design das nächste Jahrhunderts mehr herausfordern als die Bedienung der elektronischen Arbeitsstation.

**Le bureau est l'ordinateur:**
Le plus grand challenge de design sera le soutien humaine avec les stations de travail électronique.

**The office is the computer:**
servicing the electronic workstation will be the greatest design challenge.

**Software is the key to change:**
the management of office space and amenities will have as much impact on the quality of working life as the physical fabric of the office.

**Software ist der Schlüssel zur Veränderung:**
Raumgrösse, Komfort und ihre Zuordnung werden für die Qualität des Arbeitslebens die gleiche Bedeutung haben wie die Art des Bürobaus.

**Le logiciel est la clef du changement:**
La traitement de l'espace travail et son confort vont influencer la qualité de la vie professionnelle comme la structure de l'entreprise le fera.

**L'esprit du nouveau bureau**

**Neun bis Fünf stirbt aus:**
Der Arbeitstag wird ausgedehnt und variiert. Jeder wird mehr Freiheit haben, um dann und dort zu arbeiten, wo er es will.

## Nine to five is dead:

the office day will extend but also become more varied.
Everyone will have far greater freedom to work where they like, when they like.

**Le neuf à cinq est mort:**
La journée de travail va s'étendre et s'individualiser.
Chacun sera plus libre de travailler là où il veut et quand il veut.

---

**Le changement est sans pitié:**
Toutes les entreprises ont en commun la constante réorganisation et l'adaptation.

## Change is remorseless:
common to all organizations will be constant physical reorganization and adjustment.

### Der Wandel ist erbarmungslos:
Gemeinsam wird allen Organisationen nur noch die Reorganisation, der ständige Um- und Anbau sein.

Support is the heart of the workplace:
group resources such as meeting rooms, libraries, audio visual display, restaurants will make offices more like clubs than paper factories.

## Creativity is what matters most:
offices will be designed to stimulate ideas, not just get the administration out of the way.

**Le coeur du travail est dans l'environnement:**
Les salles de conférences, librairies, dispositifs d'affichages, restaurants toutes ces ressources communes vont augmenter. Les bureaux ressembleront plus à des clubs qu'à des fabriques de papiers.

**Das Herz des Arbeitsplatzes schlägt im Umfeld:**
Konferenzräme, Bibliotheken, elektronische Schautafeln, Restaurants- all diese Gemeinschaftsanlagen werde wichtiger.
Büros ähneln dann eher Clubs als Papierfabriken.

## Es kommt nur auf die Kreativität an:
Büros werden dann entworfen, um Ideen auf die Welt zu bringen. Und nicht mehr, um die Verwaltung zu verstecken.

**Farbigkeit zählt in der Unternehmenslandschaft:**
Computerfirmen, Rechtsanwälte und Banken- englische, amerikanische, japanische- sie werden alle nach dem Stil suchen, der ihnen allein steht.

**La variété est impérative pour les entreprises:**
Compagnies électroniques, avocats et services financiers-anglais, américains, japonaischercheront un style qui les démarquent des autres.

**von Francis Duffy**

**Variety matters in different kinds of organizations:**
lawyers, computer companies or financial services;
British, American or Japanese will want to find their own style that suits them best.

### The consumer is king:
more powerful, better educated and wealthier consumers will expect better quality, more interesting, more beautiful workplaces.

**Der Verbraucher ist König:**
Endlich werden auch die Verbraucher mächtiger, gesünder und gebildeter sein.
Sie erwarten bessere, schönere und interessantere Arbeitsplätze.

**Le consommateur est roi:**
Les consommateurs auront plus de pouvoir, plus d'éducation et une meilleure santé. Donc ils attendront des espaces de travail plus beaux, plus intéressants et de meilleur qualité.

11

---

*Workspirit.* Magazine pages
Vitra, Germany, 1988
Design April Greiman

*Festival d'été.* Programme pages
Festival d'été de Seine-Maritime, France, 1990
Design **Philippe Apeloig**

*The new urban landscape.* Book contents pages
Olympia & York Companies/Drenttel Doyle. USA, 1988
Design **Drenttel Doyle Partners**

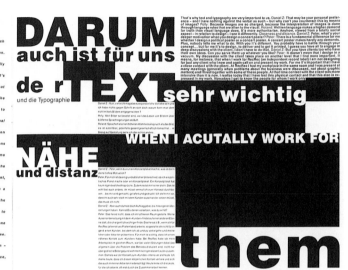

## Gegen die Konventionen

*Against conventions*

*Daniel Z: You represent – at least for Emigre – young Swiss graphic design. Or, to be precise, young Zurich*

**Daniel Z.:** Ihr repräsentiert – mindestens gegenüber "emigre" – die junge Schweizer Grafik. Oder genauer: Die junge Zürcher Grafik.

Das Gemeinsame unter euch, so scheint mir, ist das Gestalten wider die Konvention. **Roland:** Konventionen zu überwinden ist schön

*graphic design. What you have in common, it appears, is design that goes against the grain of convention.*

**Roland: It's all very well to kick against conventions, but it's dangerous to use a visual language that is finally**

gut. Aber: Es ist gefährlich, eine visuelle Sprache zu gebrauchen, die letztendlich nur von einem kleinen Kreis Gleichgesinnter oder gar

*only understood by a small circle of likeminded people – or even only by designers themselves. Daniel Z: It's*

nur noch vom Gestalter selbst verstanden wird. **Daniel Z.:** Wenn es gefährlich ist: Warum machst du es dann? **Roland:** Es gibt

*dangerous, why do it? Roland: There are several levels of working in line with conventions. In the same way that*

verschiedene Ebenen, mit Konventionen zu arbeiten. Wie es auch unterschiedliche Formen gibt, Konventionen zu verweigern oder neue

*there are various ways to go against them and pursue a new direction. In visual language, conventions can be*

Wege einzuschlagen. Im bildsprachlichen Bereich kann die Konvention im Sinne der Umkehrung, der Satire, der bewussten

*approached in a sense of reversal, or satire. Besides that there are large areas of contact border zones – so to*

Vereinnahmung angegangen werden. Daneben gibt es grosse

Berührungsflächen, Grenzland sozusagen, zwischen konventioneller

*speak, between conventional design and individual*

Gestaltung und individuellem Anspruch. Wenn ich sage, die

*claims. When I say individual deviation from convention*

individuelle Abweichung von der Konvention könne gefährlich sein,

*may be dangerous, I don't mean to defend conventions*

dann will ich damit nicht die Konventionen als unüberwindlich

*as an insurmountable prerequisite of language. To me*

Sprachvorausetzungen verteidigen. Es geht mir nur darum, das

*it's only a matter of questioning the dogma of the*

Dogma des Unkonventionellen, Individualistischen gleichermassen in Frage zu stellen. Mir persönlich steht eine dissidente, subkulturelle

*unconventional and the individualistic. A dissident,*

oder wie auch immer genannte Bildsprachen sicher näher als der visuelle Zirkus des spätkapitalistischen Realismus. **Daniel Z.:** Was

*subcultural – or whatever you like to call this visual language – is certainly nearer to me personally than a*

*visual circus of late-capitalistic realism. Daniel Z: So what in fact is visual understanding? Polly: Often the*

macht denn die visuelle Verständlichkeit aus? **Polly:** Oft ist die Botschaft eines "normalen" Plakates völlig unverständlich, doch es gibt

*message of the "normal" poster is completely incomprehensible, but there is a code to the understandable, to*

einen Code zur Verständlichkeit, zum Illusionären, zum Bild, ja sogar zum Ungestalten, eine allgemeine Glaubwürdigkeit. **Roland:** Ja,

*the illusionary, to the picture, even to the undesigned – a general credibility. Roland: That's right. Wherever one*

dort, wo mit Konventionen gearbeitet wird, gibt es diese Übereinkunft. Dort funktionieren sie. **Polly:** Scheinbar, ja. Deshalb ist es auch

*deals with conventions there is this tacit understanding. That's where it functions. Polly: It would seem so.*

gefährlich. Doch – und das ist wohl eine Gemeinsamkeit von uns hier an diesem Tisch – wir sind alle sehr vorsichtig mit dieser

*That's why it's also dangerous. And yet – and this is something all of us round this table have in common –*

scheinbaren Übereinkunft. Das Abbild einer schönen, heilen Naturlandschaft zum Beispiel, die dafür wirbt, für deren Schutz abstimmen

*we're all very careful with this apparent understanding. The image of a beautiful natural landscape, for instance,*

zu gehen, weckt in dir das Gefühl, du seist wirklich dort.

*is used to advertise its protection and arouses in you the feeling that you are really there.*

---

## DARUM auch ist für uns der TEXT und die Typographie sehr wichtig

## NÄHE und distanz

## WHEN I ACUTALLY WORK FOR them

---

Wenn wir ein politisches Plakat machen, geht es um den Umstand des Gedruckten: Du stehst vor einem Pla-

Whenever we design a political poster, it's a matter of what is actually printed. You stand in front of a poster that is nothing else but a poster, and that challenges you in act in a certain way. It tells you exactly what is printed, and nothing more.

kat, das nichts anderes sein will als ein Plakat und das dich zu etwas auffordert. Es erzählt dir genau das, was

**R i c h a r d :** You want to elucidate, I don't. To me it's neither a question of bringing across a significant message, nor of being "understood". I don't expect to be understood in the way that I myself understand my visual message.

gedruckt ist, und nicht mehr. **R i c h a r d : Ihr habt aufklärerische Absichten. Mir geht es**

**D a n i e l Z . :** But isn't it precisely your job as designer to make messages understood?

**R i c h a r d :** My task is to generate an effect. You can't define what exactly,

weder darum, eine eindeutige Botschaft rüberzubringen, noch darum, "verstanden" zu werden. Ich erwarte

or how the viewer will take in your visual message. There are an endless number of possible ways of looking at it. The only thing I can do as designer is to animate the person through my message. He himself should act, should analyze, and reproduce the visual message for

gar nicht, so verstanden zu werden, wie ich meine visuelle Botschaft verstehe. **D a n i e l Z . : Aber**

himself. So far me it's more a matter of generating an effect than wanting to teach the viewer anything.

ist es nicht deine Aufgabe als Gestalter, Botschaften verständlich zu machen? **R i c h a r d :** Meine

**D a n i e l V . :** The problem is that pictures are interpreted on the

Aufgabe ist es, Wirkung zu erzeugen. Du kannst nicht genau definieren, wie der Betrachter deine vi-

symbolic level and not on the factual level of the picture's subject matter.

**R i c h a r d :** So what's the problem?

**D a n i e l Z . :** Warum lehnst ihr sogar diese Art der Betrachtung auf?

suelle Botschaft aufnimmt. Dafür gibt es eine unendliche Anzahl möglicher Betrachtungsweisen. Das einzige,

**D a n i e l Z . :** The great image flood comes from the other side and takes over the language. Popularity is created via a universal understanding of images. If you want to be emancipated and strike against the printed word then you'll quickly become

was ich als Gestalter machen kann, ist, den Empfänger meiner Botschaft zu animieren: Er selbst soll aktiv wer-

**D a n i e l Z . :** What then is design that makes emancipated reading possible?

**P o l l y :** Because the image flood of our time seems totalitarian it is an effect due to the reluctance – or incapability – to interpret images on any other level than an

den, sich auseinandersetzen und die visuelle Botschaft für sich selbst reproduzieren. Mir geht es also mehr

darum. Wirkung zu erzeugen, als den Leuten etwas beibringen zu wollen. **AUFLEHNUNG**

**D a n i e l V . : Das Problem ist, dass Bilder auf der symbolischen Ebene gelesen werden, nicht auf**

der konkreten Ebene des Bildgegenstandes.

**R i c h a r d :** Wo liegt denn da ein Problem?

**D a n i e l V . :** Die grosse Bilderflut kommt von der anderen Seite und besetzt die Sprache. Es entsteht Po-

pularität über ein allgemeines Bildverständnis. Wenn du dem eine Lesseart gegenüberstellen willst, die eman-

zipatorisch ist, dann wirst du schnell zum Einzelgänger. **D a n i e l Z . : Was ist das, Gestaltung,**

die emanzipatorisches Lesen ermöglicht?

**D a n i e l V . : Mehr Wahrheit.**

**P o l l y :**

Unsere Arbeiten könnte man sehr leicht verstehen, wenn man sie nicht immer symbolisch lesen wollte.

Weil die Bildflut unserer Zeit totalitär wirkt, eine Wirkung, die durch den Unwillen oder die Unfähigkeit ent-

steht, die Bilder auf einer anderen Ebene reden zu lassen als auf der lediglich unterschwelligen – spricht uns

die symbolische Ebene an. Es geht uns um Wahrheit.

**P o l l y :** Our work could be easily understood if one didn't always read

**P o l l y :** Because the image flood of our time seems totalitarian it is an effect

**D a n i e l Z . :** More truth.

Wünsche und Zwänge. Unsere Arbeit besteht darin, die irgendwelche Lücken aufzutun, Lücken, in denen die

the subliminal, or unconscious level. A production of images in an impenetrable array of wishes and constraints. Our work is to open up gaps. Spaces in which you get your text back on the floor. Where not everything is plastered over with pre-digested images.

sublimiert, oder unbewusst erscheint. Eine Produktion von Bildern in einem undurchdringlichen Gewirr von unerfüllbaren reproduzierbaren

Wünschen und Zwängen. Unsere Arbeit besteht darin, die irgendwelche Lücken aufzutun, Lücken, in denen du

Füsse wieder auf den Boden kriegst. In denen noch nicht alles zugepflastert ist mit vorgekauten Bildern.

**D a n i e l V . : Das Problem ist, dass Bilder auf der symbolischen Ebene gelesen werden, nicht auf**

---

*That's why text and typography are very important to us. Daniel Z: That may be your personal preference – and I have nothing against the verbal as such – but why can't you counteract this by means of images? Polly: Because images are so charged, because the interpretation of images is done through language rules that are alien to the visual. Roland: Written language makes a higher demand for truth than visual language does. It's more authoritarian. Anyhow, viewed from a totally social aspect – in relation to design – I see it differently. Closeness and distance. Daniel Z: Peter, what's your deeper motivation when you design a concert poster? Peter: There is a fundamental difference for me whether I design a political poster or a concert poster. A concert poster makes hardly any demands. Plus, nobody tells me what to do. With you it's different. You probably have to battle through your concept of what needs to be said. For me it's to design, to deliver and to get it printed, I guess you have all to engage in deep discussions with the client. I don't have to do that. Daniel Z: But you have clients too who have their own ideas. Can you serve them up whatever you like? Peter: It doesn't mean that I design in a vacuum. My discussion with the client takes place on another level that I find more important. It means, for instance, that when I work for RecRec (an independent record label) I am not designing for just any client who I now and again call on and present my work. For me it's important that I have a close contact with the client. At RecRec I had my workplace in the same room and I was present at many meetings (generally when problems about the business were discussed, not about graphic matters) and I lived together with some of these people. At that time contact with the client was more intensive than it is now. I realize today that I have held this physical contact and that this also is expressed in my work. Nowadays I get to know the people for whom I work only*

---

This is not very easy for me. I find it's basically more simple and honest to do graphic design for people I know than for strangers who would quite likely be unsympathetic to me. In large agencies and with big clients the graphic designer no longer has any direct contact with the client. Somebody is engaged specifically for the job of making the contacts. Richard: The fact that a client comes from practically the same background as I do is not important. What is important is that I am able to think on his/her wavelength and that I can accept what he/she does. It is often much better to gain some distance to understand who he and what she wants - about the same distance a psychoanalyst has from his/her patient. Daniel Z: Is the nearness to your client sufficient. Or do you need a concept first, when you design a concert poster, Peter? Peter: Well, I do posters this way: I know the music, I leaf through magazines, copy a few pictures - and start. I don't first stop to consider what it is or what should actually be set down. For a political poster I would approach the task in a different way. I would first consider what the message had to be, etc. ... I would probably not do a political poster at all. When I look at all these posters, there is seldom anything that I like - not even those coming from the left. This is sufficient reason for me not to work for them. They're not interested in what I'm doing anyhow, so it's out of the question. It is difficult to experiment in this field. Roland: I see it the same way. It is unimportant to me what the design is for - whether for the opera house, rock music, the museum of design or Citroën. It's far more important what the relationship is between the designer and the client during the design process. This is the point where those designers who make a poster for a rock band, whose music they are clearly addicted, differ from those whose task is simply to increase sales figures. Peter: I'm not saying that discussions with the client are unimportant to me. But that they have no significant effect on the end result. Polly: The cultural difference to clients often has a productive effect. It spurs you on to do things you otherwise need not do.

opposite: *Emigre* "Heritage" issue
Magazine pages
Emigre Graphics, US, 1990
Design Richard Feurer
Peter Bäder
Polly Bertram & Daniel Volkart
Roland Fischbacher
Margit Kastl-Lustenberger
Daniel Zehntner

*Steelworks*. Book pages. Why Not Publishing, UK, 1990. Design Why Not Associates

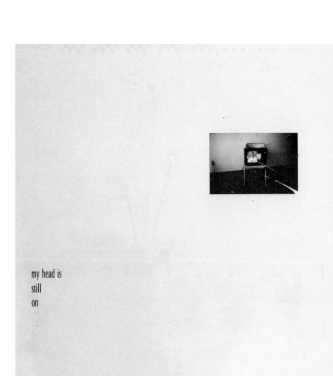

my head is
still
on

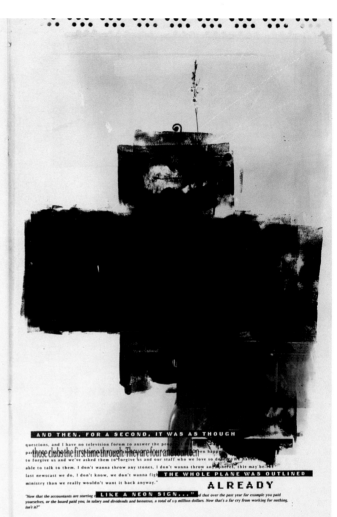

AND THEN, FOR A SECOND, IT WAS AS THOUGH

questions, and I have no television forum to answer the peop...
par those clubs the first time through. They are four and fourteen en happ...
to forgive us and we've asked them to forgive us and our staff who we love so de... we have
able to talk to them. I don't wanna throw any stones, I don't wanna throw any... this may be t...
last newscast we do, I don't know, we don't wanna figh THE WHOLE PLANE WAS OUTLINED
ministry than we really wouldn't want it back anyway." ALREADY

"Now that the accountants are starting... LIKE A NEON SIGN..." d that over the past year for example you paid
yourselves, or the board paid you, in salary and dividends and bonuses, a total of 1.9 million dollars. Now that's a far cry from working for nothing,
isn't it?"

*Emigre.* Magazine pages
Emigre Graphics, USA, 1987
Design Rudy VanderLans

and
continue
to watch
the movie:

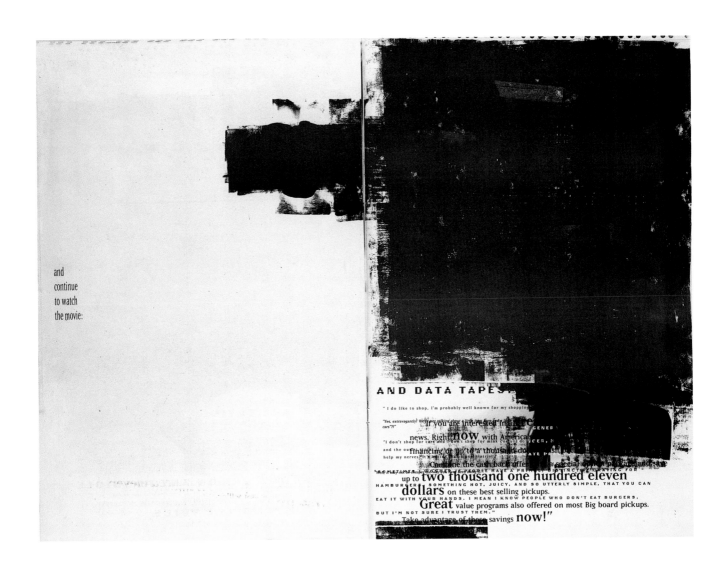

AND DATA TAPES

" I do like to shop, I'm probably well known for my shopping

"Yes, extravagantly! Well...
cars'?!

If you are interested in a new
news. Right now with American
"I don't shop for cars and I won't shop for mink coats do deer.
and the out financing or up to a thousand do
help my nerves. It's not... Combine the cash back offer a special

up to two thousand one hundred eleven
HAMBURGER. SOMETHING HOT, JUICY, AND SO UTTERLY SIMPLE, THAT YOU CAN
dollars on these best selling pickups.
EAT IT WITH YOUR HANDS. I MEAN I KNOW PEOPLE WHO DON'T EAT BURGERS,
Great value programs also offered on most Big board pickups.
BUT I'M NOT SURE I TRUST THEM."
Take advantage of these savings now!"

that are wonderful and that I need. I'd like to find an economical way to make the paintbox be more **painterly** and maybe be more **ambiguous** in the final result. Sometimes, **accidentally**, this happens because I am new at it, but I don't feel like I'm really controlling that yet. I'm kind of missing that **painterly feeling that you can get on a Mac.** If you airbrush on the Mac, it's so rough that you always get these wonderful **gestures** out of things, because it is making decisions and approximations at every corner! With the graphic paintbox, the resolution is so high that it's all very accurate, there are no visible approximations. **Emigre:** Will the Macintosh contribute to a change in graphic design mostly in the area of production, or will it influence design aesthetics as well? **April:** Both! In principal, I would agree that the Mac saves us time and all that. But what I experience is rather than doing something quickly, we're **looking at more** possibilities. Instead of doing more work we are **seeing more** options. Now we spend **more time visualizing and seeing things,** and before the Mac, we spent more time doing things. You wouldn't look at twelve different sizes of a headline type, because it would involve setting the type and then statting it and you would just say, "Oh come on, I don't have to try this subtler difference." But with the Mac, once the information is stored, you can just look at seventy-two thousand variations. And then the accidents happen and you say, "Oh that's so much better, why

Glenn Suokko. Back cover *Emigre 10.*

---

Glenn Suokko, Minneapolis, 6/20/88

**Emigre:** Who had the idea of acquiring Macintosh computers at Cranbrook? The students or the faculty?

**Glenn:** We were one of the original three design schools chosen for the Apple/Design School Consortium. Apple generously donated both hardware and software to the Cranbrook Design Department and was very helpful in introducing us to this new phenomenon called the Macintosh. Hugh Dubberly from Apple came out for a few days to help set up the network and offered some valuable training seminars. Kathy and Mike McCoy (Co-Chairs, Design Department) were very enthusiastic about the possibilities the computer could offer. Many of my classmates had never used a computer before, so it represented not only a new tool to learn, but a new way of working.

**Emigre:** Were there specific classes taught on the Macintosh?

**Glenn:** Cranbrook does not teach any technical skills and the program has no formal instruction. For me, the Mac's were a very timely arrival; they arrived the first day of my second year at Cranbrook. Although we had no specific technical training for the Mac, Kathy McCoy assigned design projects that involved using the computer, and just by using it, we quickly learned the technical aspects.

**Emigre:** What did the assignments involve?

**Glenn:** These projects were designed to explore the Macintosh as a design tool and to see if it would inspire our own design sensibilities in any new or different way. My particular group did not have specific design assignments using the computer. However, the first year graphic designers started the program using them. Projects were designed to incorporate many of the software programs, such as PageMaker and Illustrator. There was one particular typographic assignment that we all did, where I set some type, then laser-scanned it and put it into a paint program, printed it out, statted it, ran it through the water and cut up part of it, scissored it, photographed it, laser-scanned it again, and basically ran it through all the technology available in the studio to see what would happen. I let the various technologies take over and through this process, discovered some interesting formal qualities. We were offered complete freedom in these projects and we were never told we had to use the computer exclusively. Using the Mac at Cranbrook was a matter of choice combined with a lot of encouragement. The computer was available to all of us to use and explore in any way we wanted to. We had no technical instruction at all, but we learned how to use the Mac nevertheless. People who can design pick it up rather quickly. Although some of my classmates resisted it totally, other classmates took to it fairly soon and began to use it exclusively.

**Emigre:** What did the students who resisted it rebel against?

**Glenn:** I think the feeling was that the Macintosh could not do anything more than we could using traditional design tools.

**Emigre:** Do you feel you can do more with it than with traditional methods?

**Glenn:** The Macintosh is an analogue to our traditional design tools. It is a typesetter, drawing board and maybe, pencil and paint brush, sketch pad, and filing cabinet, but it is all focused in one tiny electronic box. I must admit I have become completely addicted to using it. The Macintosh is not much different from the design tools we traditionally use, despite its seemingly progressive capabilities. However, it does allow us firsthand control and the opportunity for endless changes and experimentation.

**Emigre:** I have seen you use it in a very experimental way. When it comes to type, for instance, you have created new letterforms that are more illustration than type. Will you continue these experiments?

**Glenn:** We have all seen the value of the Mac as a production tool and how easy it is to typeset, construct and output literal pages but there are a lot of undiscovered possibilities the computer suggests. At Cranbrook, Kathy McCoy really pushed us to explore 'the other side' of the computer. I became very interested in developing typography as image, which came out of exploring this 'other side.' At Cranbrook, we tried to push the computer in different ways by using it unconventionally so

---

Glenn Suokko. Detail from *Mediate,* a typographic experiment.

don't I go that way?" And then you are off on a whole new idea. This pioneering, **where you don't have an aesthetic yet and you don't have tradition,** is both time-consuming and wonderful. **To feel lost is so great.** There are only a few areas in this very controlled industry that you can feel like that. **Emigre:** Where will these experimentations lead to? **April:** There are two ways that we are pushing this technology. One is by **imitating and speeding up normal processes** of different disciplines, such as production and typesetting. Here, the **technology is a slave** and is simulating what we already know. But I think that, if we all keep going the way we are going and other people jump in, all desperate for **new textures/new languages,** then the other area in which it's going to advance is a **new design language.** Rather than get the language that's built-in to speak to you in English, you say, well, I know it can speak English, it does that very well, but there's also a new language. What do digital words really mean and say? There is a **natural language in that machine** and I am interested in finding out what that is, and where the boundaries are. **Emigre:** How come you haven't done any type design on the Macintosh? **April:** There just isn't enough time to do everything. I am such a fanatic about type, and I am so critical and such a perfectionist about it, and there are so many great typefaces that exist. It would take me a year to come up with anything decent and I just don't have the time. **Emigre:** Do you think that there will be an increase in gimmicks and copying due the Macintosh? **April:** Sure, but that happens with any new technology.

I don't worry too much about that. The Mac's so easy to use. It's going to be very scary. It'll be interesting to see what will happen in another three years or so. Kids know how to use this now and everybody will be **modeming** and using **electronic bulletin boards** and what not. So yes, there'll be a lot of mimicry and copying, but it will make the people with traditional design backgrounds and the people with the high-end equipment who know what they are doing push themselves further. For a while, communications may be really ugly and bad. There are going to be large cor-

TYPE

PURE

IMM PURE TYPE

[ver -nak-yoo- ]

Perfo 3

Performance, Muziek, Installaties.

LANTAREN VENSTER

11 t/m 18 mei 1985

*Doorbraak* (Breakthrough). Exhibition poster. Damrak Amsterdam, The Netherlands, 1989
Design The Thunder Jockeys

wenst u een *gelukkig*

opposite:

*Intomart wenst u een gelukkig 1986* (Intomart wishes you a happy 1986). Best wishes card. Intomart, The Netherlands, 1986
Design Ton van Bragt Studio Dumbar
Photography: Lex van Pieterson

*European illustration.* Book pages. Booth-Clibborn Editions, UK, 1989
Design The Thunder Jockeys
Photography: Peter Ashworth

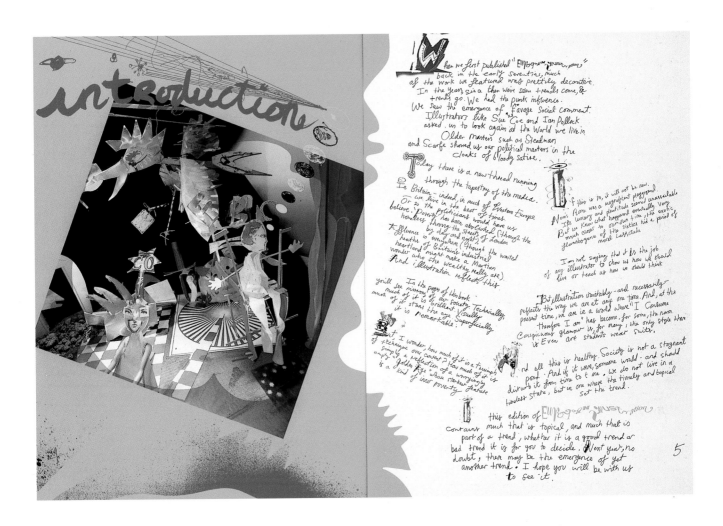

16th

89-90

European illustration

© edited by Edward Booth-Clibborn ©
~ edité par Edward Booth-Clibborn ~
— herausgegeben von Edward Booth-Clibborn —

jury

Michel de Boer

Jerry Hibbert

Mary Lewis

Richard Markell

Geld Stamenkovits

Brian Webb

European illustration

*Current work from artists studios*
Poster/mailer. Detroit Focus Gallery, USA, 1987. Design Edward Fella

*Vickie Arndt/Peter Lenzo*
Poster/mailer. Detroit Focus Gallery, USA, 1990. Design Edward Fella

opposite:
*European illustration.* Book page
Booth-Clibborn Editions, UK, 1989. Design The Thunder Jockeys

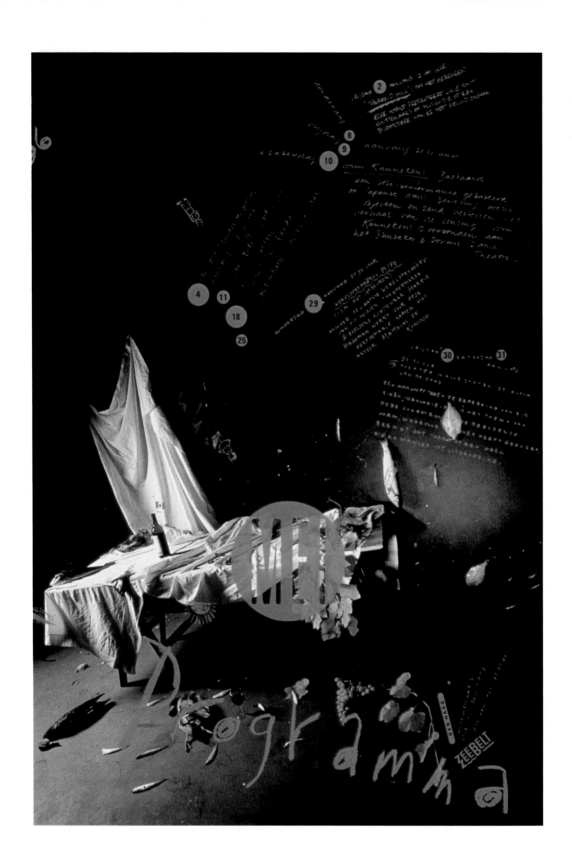

*Mei programma*. Programme poster
Zeebelt theatre, The Netherlands, 1986
Design Linzi Bartolini
Gert Dumbar
Esther Vermeer
Studio Dumbar
Photography: Lex van Pieterson

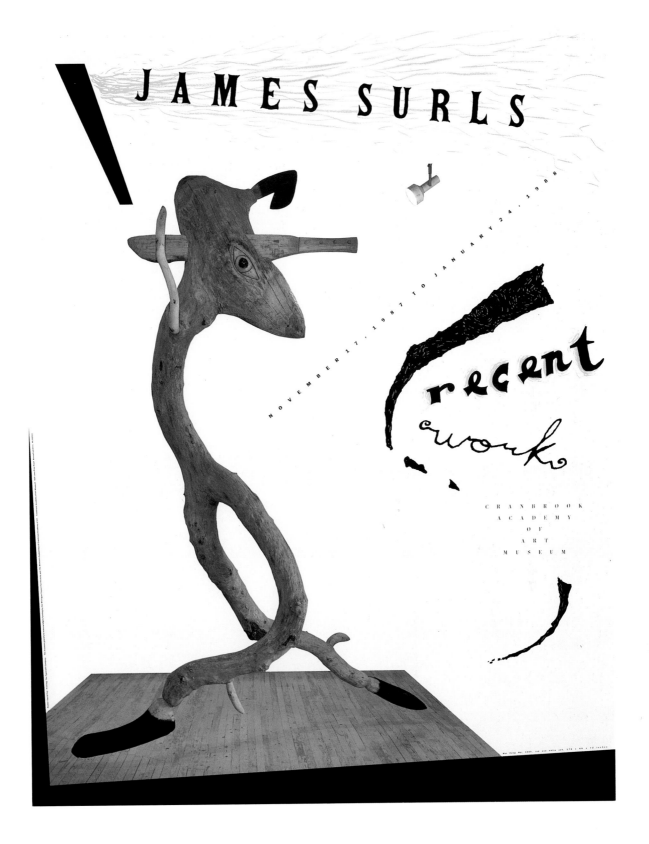

*James Surls*. Exhibition poster
Cranbrook Academy of Art Museum, USA, 1987
Design David Frej

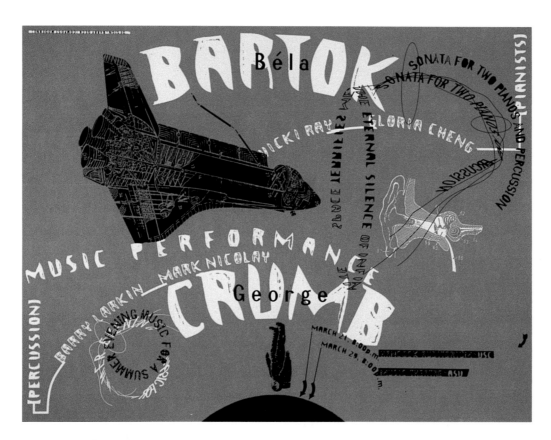

above: Poster. USA, 1989. Design Barry Deck

*Nu-bodies.* Poster/flyer. Detroit Focus Gallery, USA, 1987. Design Edward Fella

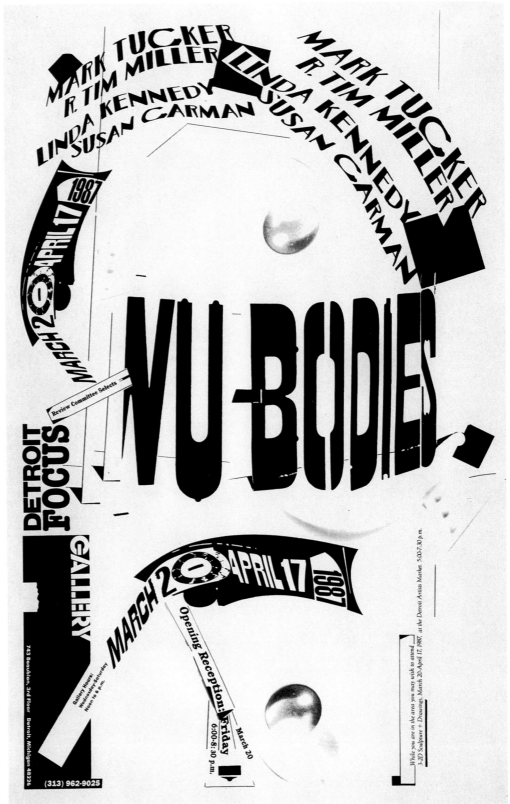

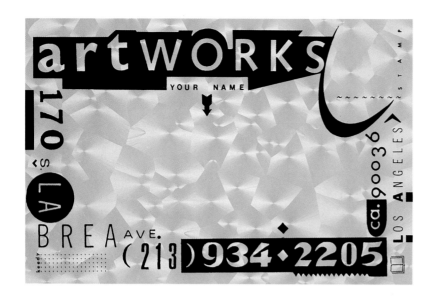

above: Postcard. Artworks, USA, 1988
Design Jeffery Keedy

*Excavator-Barcelona-Excavador*. Pages from an artist's book. UK, 1986.  Design Jake Tilson

opposite: *Continuum.* Poster/mailer
Detroit Focus Gallery, USA, 1990
Design Edward Fella

**Reception:** FRIDAY, OCT. 12TH, from 5:30—8:30pm

Oct 12 ~ Nov 10th 1990

# CONTINUUM

AVERY BOONE

JAMES H. DOZIER

MARIA-THERESA FERNANDES

RUTH LAMPKINS

RICHARD LEWIS

STEVEN MEALY

AARON IBN PORI PITTS

REGINALD GAMMON

ESDRAS M. SANTIAGO

CURATORS
GILDA Snowden
Lester Johnson

DETROIT
FOCUS GALLERY

743 Beaubien
DETROIT, MI 48226
3rd fl.
tel. (313) 962~9025
hrs: WED—SAT. 12—6 P.M.

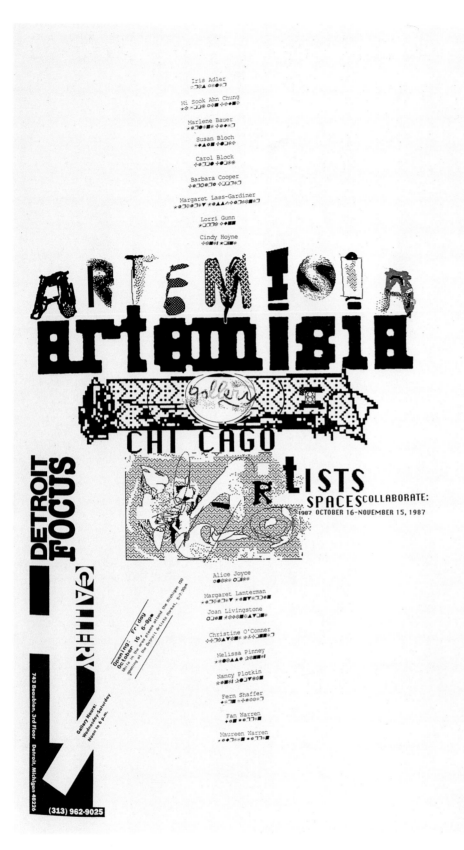

*Artemisia Gallery*
*Chicago Artists Spaces*
Poster/mailer
Detroit Focus Gallery, USA, 1987
Design Edward Fella

opposite:
*i-D.* Magazine pages
Terry Jones/Tony Elliot, UK, 1990
Art director Stephen Male Nice

the i-D Forums
## MUSIC

Lisa Anderson (BMG/RCA), Norman Cook (Beats International), Dave Dorrell (ex- M/A/R/R/S/, DJ, remixer) Boy George (Jesus Loves You), MC Mell'O' (UK rapper) and Tony Wilson (Factory Records /media mouth).

**Chaired by John Godfrey**

Large display type overlaid on image: why are there so few **black** people in the record industry? ARE WE LIVING IN THE **'60s?** WILL THE **MANCHESTER** BANDS MAKE IT IN AMERICA? HAS DANCE MUSIC BECOME TOO **COMMERCIAL?** WILL TONY WILSON **EVER** LEARN TO KEEP HIS MOUTH **SHUT?**

**WHAT DO YOU THINK THE BIGGEST PROBLEM FACING THE RECORD INDUSTRY IS NOW?**

**TONY WILSON:** Personally, the problem for the British record industry now is breaking the British scene in America.

**NORMAN COOK:** Is it such a big deal?

**TONY WILSON:** Yes, it makes a massive difference.

**BOY GEORGE:** Financially, yeah.

**TONY WILSON:** Financially, yeah. It makes an enormous fucking difference financially.

**BOY GEORGE:** Is there anyone making money out of dance music in this country?

**LISA ANDERSON** and **TONY WILSON** in unison: Yes.

**TONY WILSON:** If you get albums out of it – no-one makes money out of dance music per se if it remains 12" single orientated, only if you have an album going.

**DO YOU THINK THE BRITISH SCENE TODAY HAS ANY SIMILARITIES TO THE '60S?**

**TONY WILSON:** Yeah, drugs.

**NORMAN COOK:** Is it that simple?

**BOY GEORGE:** I think it is drugs.

**DAVE DORRELL:** Everyone is giving it hippy this and that, but they're all mods really, they should all be wearing straight suits.

**TONY WILSON:** But none of them were born in the '60s. When everyone tried to revive psychedelia, like the Liverpool bands tried to do in '81/'82, it didn't work. It could only really happen again when young people hadn't experienced it. And there's an unselfconsciousness to it now which was never there in the '60s, and that's what makes it new.

**BOY GEORGE:** I think all it is is the drugs that have got a lot of normal kids from the suburbs into music that they probably weren't even into before, there's a lot of people dancing now who weren't into music before.

**NORMAN COOK:** I still don't think they're into music.

**TONY WILSON:** Course they are, course they are, course they are!

**NORMAN COOK:** I think they're into it through fashion.

**TONY WILSON:** Noo!

**BOY GEORGE:** And I think the record companies are just destroying everything.

**LISA ANDERSON:** Here we go, here we go.

**BOY GEORGE:** They are, they are destroying everything.

**LISA ANDERSON:** Thank you George.

**THE 'SIGN UP ANYTHING FROM MANCHESTER' MENTALITY?**

**LISA ANDERSON:** Certainly not.

**TONY WILSON:** We'll sign anything.

**LISA ANDERSON:** I wouldn't sign just anything from Manchester, anyway it's all been signed up.

**TONY WILSON:** If you think it's going to make money, and clearly several people think that the new scene is going to make money...

**LISA ANDERSON:** It's going to make money for someone.

**TONY WILSON:** It's making money already, and as I said, the only problem left is if it breaks in America, cos if it does it will make an awful lot of money for everybody.

**DAVE DORRELL:** Do you think it will?

**TONY WILSON:** Er, 60/40 – about the same odds as keeping the Hacienda open, slightly more than even.

**BOY GEORGE:** I don't know if America's that into it though.

**TONY WILSON:** But it depends if they're going to wake up. **The kids who were buying Jason and Kylie two years ago are now 11, and 11 year olds are buying Stone Roses, Happy Mondays and the rest of it.** And if that's happening in Britain, one has to wonder if American kids who are buying New Kids On The Block now, in a year's time they're going to be older and they're going to see this exciting stuff coming out of this country.

**NORMAN COOK:** Well let's face it, if 11 year old English kids can cope with The Happy Mondays, 20 year old Americans must be able to, mustn't they?

**LISA ANDERSON:** Not necessarily. They're so susceptible to what is sold to them.

**NORMAN COOK:** I reckon Americans are hung up on the whole dream of rock'n'roll, the James Dean element. I don't think they can cope with anything unless it has the essential rock'n'roll ingredient.

---

the i-D Forums
## books

Pete Ayrton (Serpent's Tail), Michael Bracewell (novelist), Christopher Fowler (horror writer), Giles O'Brien (4th Estate) and Mike Phillips (crime writer).

**Chaired by Steve Beard and Jim McClellan**

Large display type overlaid on image: **why** aren't crime, **horror** or science fiction taken **seriously?** IS THE **BOOKER** PRIZE A GOOD THING? is there such a thing as **english literature?** do we need **hardbacks?** WHY DOESN'T MIKE PHILLIPS MIND IF NOBODY READS HIS BOOKS?

**What do you think the Booker Prize represents and is it desirable?**

**MIKE PHILLIPS:** I don't have anything against the Booker Prize. Unfortunately I don't think I'm going to get it. But does it represent a kind of oppressive literary culture? I don't think that it does in itself. I think it reflects a literary culture that comes out of a static notion that the country has of itself, never mind literature. And I think the reason that can be oppressive, if it's oppressive at all, is because we haven't yet begun to reassemble the elements of an English or British identity and understand it. So in a way, the whole superstructure that's represented by the Booker Prize and the publishers and all the rest of it is, in a sense, **alien** to lots of people writing now. Because it doesn't share the identity that they're describing and assembling in Britain now.

**CHRISTOPHER FOWLER:** It represents a sort of stratified upper middle class, and it's almost a genre in itself, in that you can classify a book as a Booker book. It's almost as if the books are being chosen for the ability to find some permanence in some pantheon of future literature. It seems to be very narrow, and it keeps dangerously away from anything realistic, or too much outside of what the average person who sees the little sticker on the shelves saying 'Booker Prize short-listed', experiences.

**MIKE PHILLIPS:** You can see the style - it's the sort of book that when you open it you think, **Oh shit this is going to be really hard to read.**

**GILES O'BRIEN:** You've got to remember that the reason that money is there is that Booker want to see their name on those nice little printed plaques that go round with the books. Each year it's a completely different set of six judges, mind you these people are chosen cos they represent some kind of literary establishment, and I think they feel a pressure to represent that establishment. But I think they also feel a pressure to produce a popular winner, one that people will actually read and enjoy. And that is because it is a marketing exercise, it's not conceived as a literary exercise, it's very useful for publishers, it's very useful for Booker - although I don't actually know what Booker do other than sponsor the Booker Prize.

**MIKE PHILLIPS:** I'll tell you what Booker has done - **Booker owned my country.** The country where I was born, Guyana, you walk down the high street and everything says Booker, Booker, Booker. I've always found it a slightly galling to come here, and to find that Booker is handing out money in this way.

**PETE AYRTON:** To be fair it's changing, and to a certain extent the way it's changing is reflected by the jury and who's chosen, and the things we're doing and other people are publishing. I mean, last year Maggie Gee and Ed White were on the jury, this year Kate Saunderson, and James Kelman was short-listed last year - these are steps forward. You know, one's looking at it as if it's this dead weight that every year comes up with Anita Brookner, which happens some years, but it is changing, and to a large extent it depends on who's in the jury. To what extent they will continue to get interesting and non-mainstream people onto the jury though, one doesn't know, but it's the book trade that is the first to complain. When Keri Hulme won, the New Zealand feminist novelist, it was the book trade who complained cos they couldn't sell the book. The problem is the book shops, not Booker or the people who select the book.

**CHRISTOPHER FOWLER:** So are there some books which the audience would buy if it won the Booker?

**GILES O'BRIEN:** Yeah, it makes a tremendous difference.

**PETE AYRTON:** But I think that one can get too hung up on this thing - obviously it's been good for books, it's been good for writers, it gets TV coverage, it raises the profile of books and makes this country more book conscious, which God knows, you know...

**MICHAEL BRACEWELL:** I agree with Pete, the fact that Kelman and Banville got on the short-list last year - I thought that was very much a step in the right direction. I have this sneaking suspicion that any of us who couldn't help but feel rather pleased.

**PETE AYRTON:** And everybody's doing it now - the Sunday Express have got one, Whitbread have got one - it can't be bad, all these people throwing money at writers.

**CHRISTOPHER FOWLER:** The Sunday Express have got one?!

**PETE AYRTON:** Yeah, I think it's the richest, and there's one in Ireland, the Guinness one, which is £50,000.

**CHRISTOPHER FOWLER:** **I didn't think the people who read The Sunday Express bought books, I thought they watched TV.**

**Are genre writers perceived as being on the margins of literature?**

*Last night a DJ saved my life.* Club poster. Parco, Tokyo, 1990

Design Richard Bonner-Morgan, Neil Edwards, Stephen Male Nice

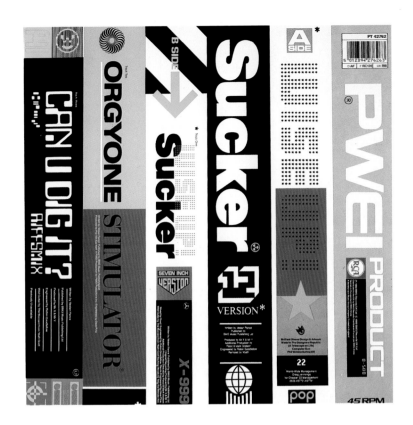

*Wise up sucker.* 12" single cover (back)
RCA, UK, 1989
Design Designers Republic

opposite: *This is the day . . . this is the hour . . . this is this!*
Album cover (back). RCA, UK, 1989
Design Designers Republic

EMIGRE

heritage

No.14/$7.95

opposite:
*Emigre.* Magazine cover. Emigre Graphics, USA, 1990
Design Rudy VanderLans

*Tegentonen.* Concert poster. Paradiso Amsterdam,
The Netherlands, 1986
Design Max Kisman

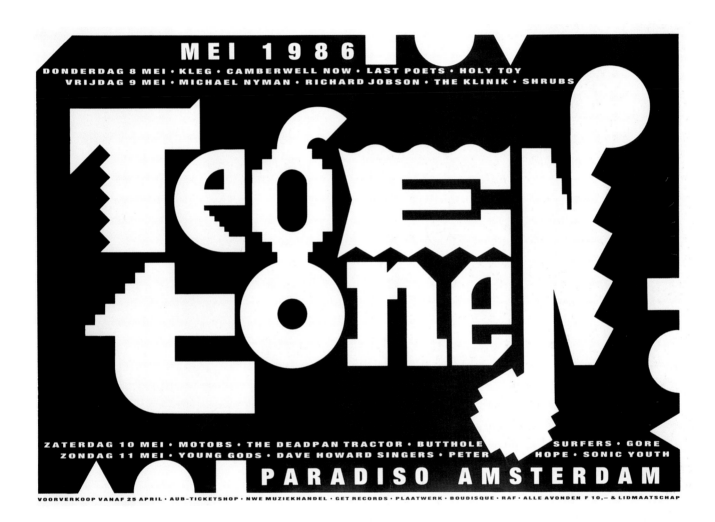

below: *Breakfast Special*
Pages from artist's book. UK, 1989
opposite: *Excavator-Barcelona-Excavador*
Pages from an artist's book. UK, 1986
Design Jake Tilson

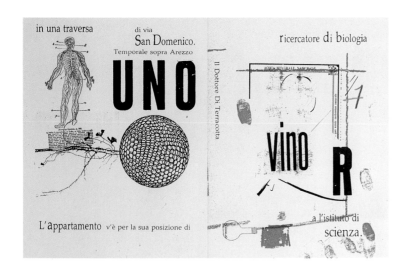

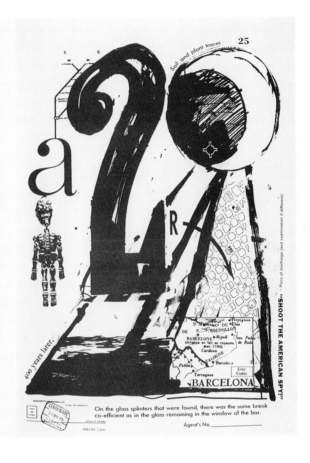

# EMIGRE

THE
MAGAZINE
THAT
IGNORES
BOUNDARIES

PRICE:
$7.95

*Design Department*

## Cranbrook

graphic

## design

*special*

Change

*special*

X

ISSUE

## Dutch

*Several Designers*

*Emigre.* Magazine cover. Emigre Graphics, USA, 1988
Design Glenn Suokko

*Binary race.* Booklet. Emigre Graphics, USA, 1991
Design/photography Rudy VanderLans

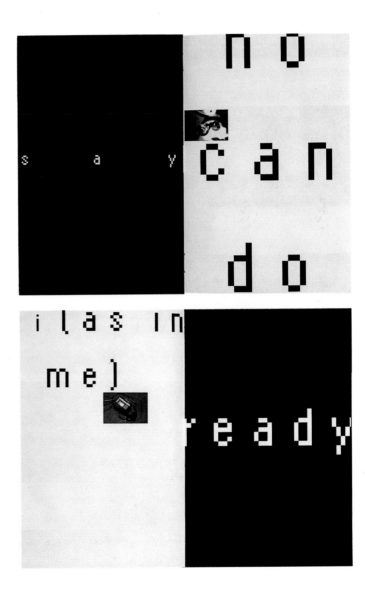

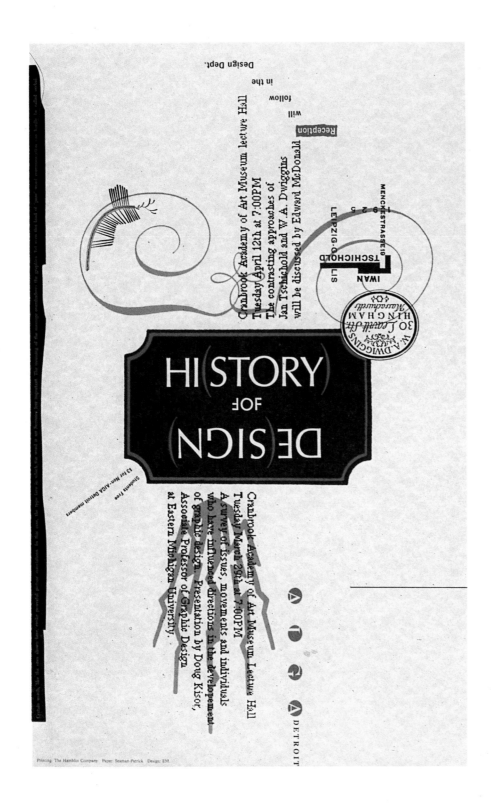

*History of design/story of sign.* Poster/mailer
American Institute of Graphic Arts Detroit, USA, 1988. Design Edward McDonald

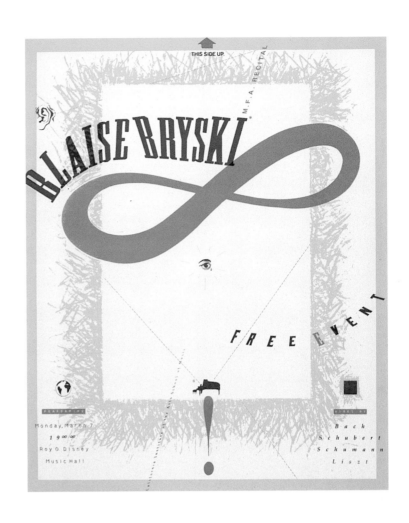

above:
*Blaise Bryski*. Concert poster. California Institute of the Arts, USA, 1988. Design Barry Deck

below:
*Fournier le jeune*. Poster. USA, 1985. Design Edward McDonald
Cranbrook Academy of Art

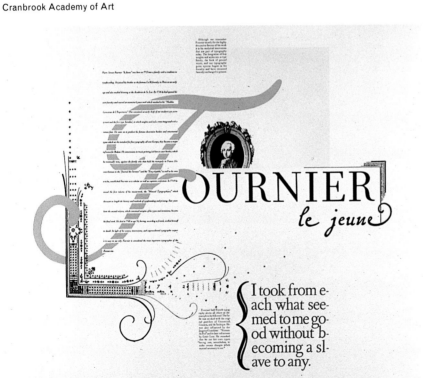

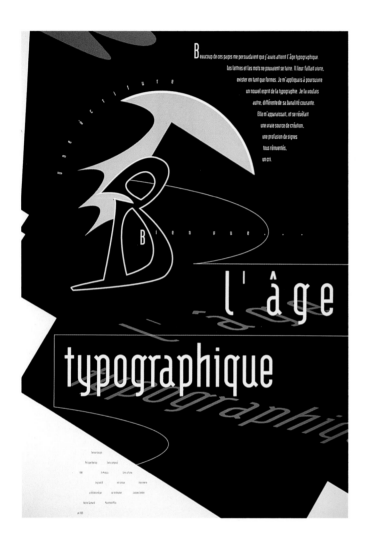

*L'âge typographique* (The age of typography). Poster. France, 1989
Design Philippe Apeloig

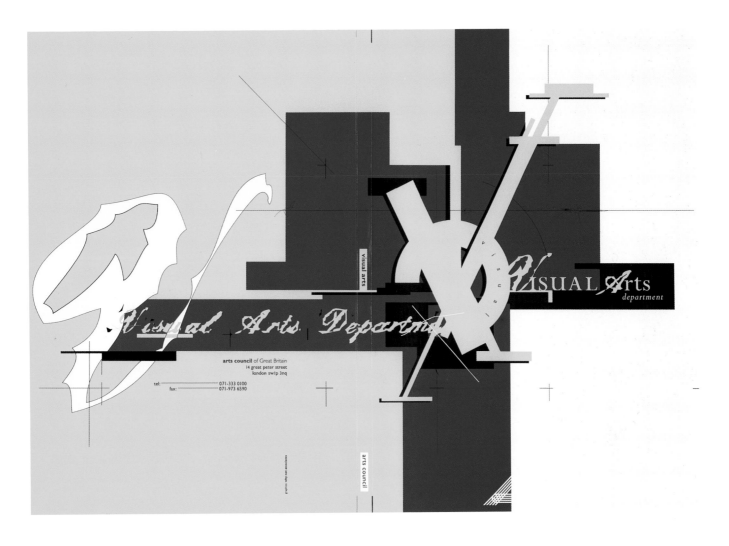

*Visual arts department.* Folder. Arts Council, UK, 1991
Design Why Not Associates

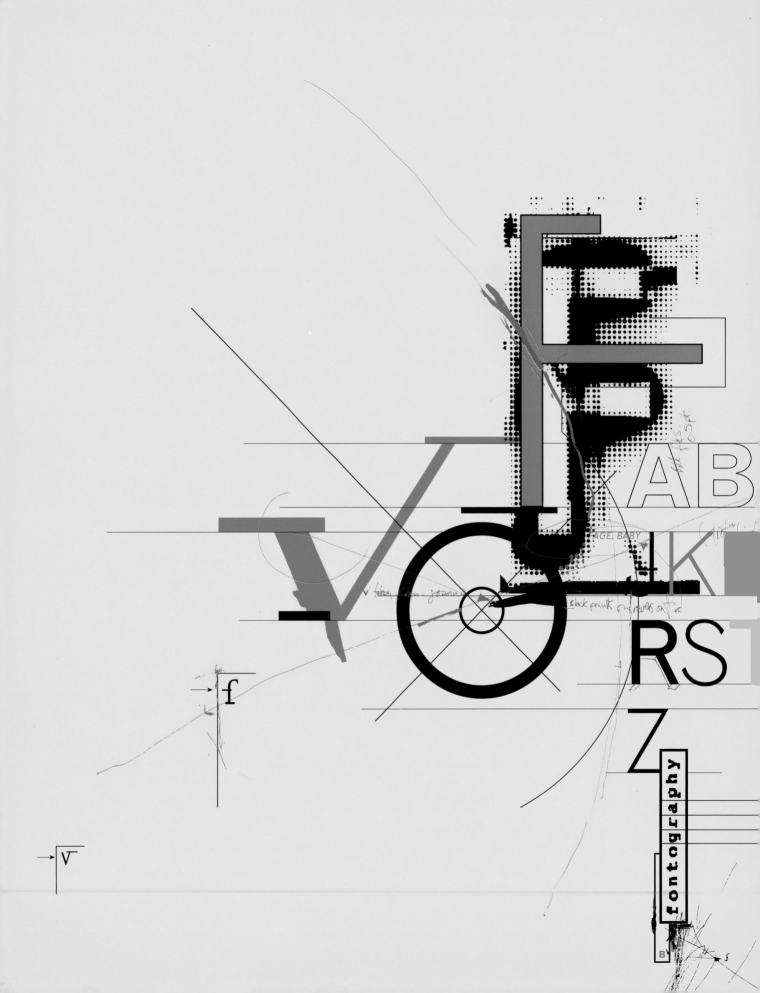

X
F

fuxx n tgy naxx a phy

f    o    nrrrmT

X
g

FONTOGRAPHY    G    FONTOGRAPHY

X
Y
x

X

X

C D E F G H I

M N O P Q

of    fontography

U V W X Y

in

A B C D E F G H
a b c d e f g h
I J K L M N O P Q
i j k l m n o p q
R S T U V W X Y Z
r s t u v w x y z
1 2 3 4 5 6 7 8 9 0

*Industria Inline.* Linotype, UK, 1990
opposite: *Arcadia.* Linotype, UK, 1990
Design Neville Brody

ustria

A B C D E F G H
a b c d e f g h
I J K L M N O P Q
i j k l m n o p q
R S T U V W X Y Z
r s t u v w x y z
1 2 3 4 5 6 7 8 9 0

rcadia

A B C D E F G H
a b c d e f g h
I J K L M N O P Q
i j k l m n o p q
R S T U V W X Y Z
r s t u v w x y z
1 2 3 4 5 6 7 8 9 0

*Oakland Ten.* Emigre Graphics, USA, 1985. Design Zuzana Licko

*Matrix Regular.* Emigre Graphics, USA, 1986. Design Zuzana Licko

matri

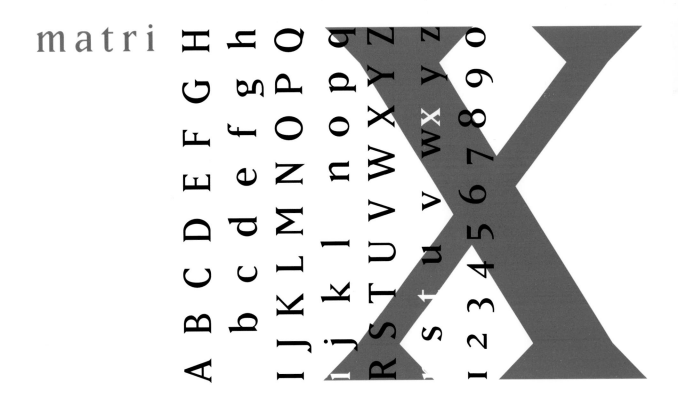

ABCDEFGH
bcdefgh
IJKLMNOPQ
ijklnopq
RSTUVWXYZ
rstuvwxyz
1234567890

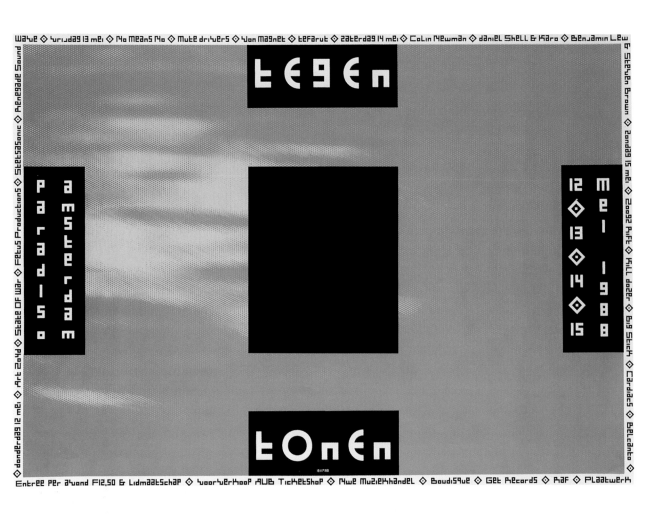

above:
Concert poster. Application of Tegentonen
Paradiso Amsterdam, The Netherlands, 1988

*Tegentonen.* The Netherlands, 1988-90
Design Max Kisman

mo *dular* lar

*Modular Regular.* Emigre Graphics, USA, 1985. Design Zuzana Licko

ABCDEFGH

abcdefgh

IJKLMNOPQ

ijklmnopq

RSTUVWXYZ

rstuvwxyz

1234567890

*Zwart Vet.* The Netherlands, 1987 (capitals), 1990 (lowercase and special characters). Design Max Kisman

*Scratch Regular.* FontShop "FontFont" series, The Netherlands, 1990. Design Max Kisman

*Vortex*. FontShop "FontFont" series, The Netherlands, 1990. Design Max Kisman

l u n a t i

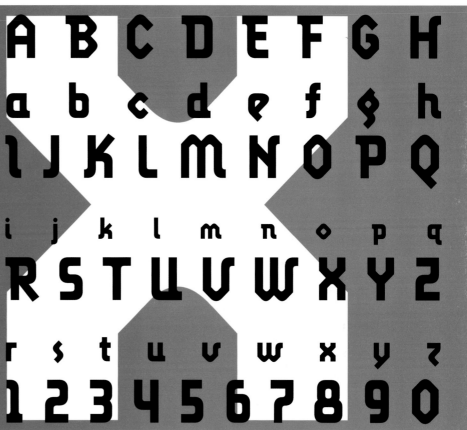

*Lunatix Bold.* Emigre Graphics, USA, 1988. Design Zuzana Licko

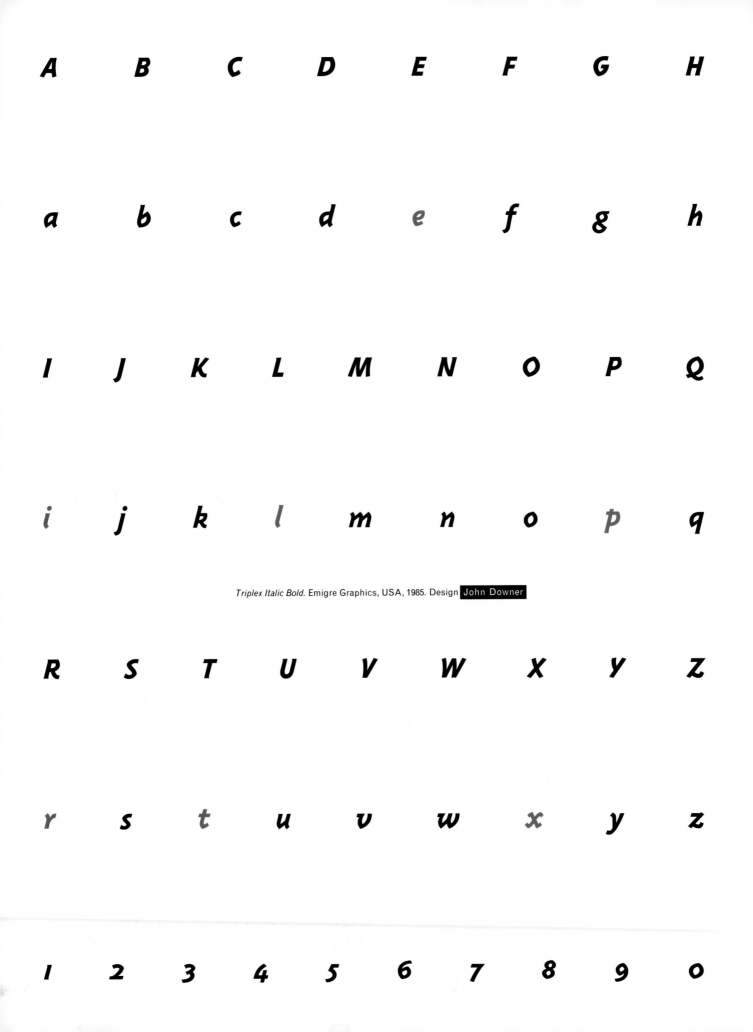

A B C D E F G H

a b c d e f g h

I J K L M N O P Q

i j k l m n o p q

*Triplex Italic Bold.* Emigre Graphics, USA, 1985. Design John Downer

R S T U V W X Y Z

r s t u v w x y z

1 2 3 4 5 6 7 8 9 0

# slim

Jacque Slim, Regular and Fat. FontShop, The Netherlands, 1990. Design Max Kisman

A B C D E F G H
a b c d e f g h
I J K L M N O P Q
i j k l m n o p q
R S T U V W X Y Z
r s t u v w x y z
1 2 3 4 5 6 7 8 9 0

# regular

# Fat

*Brokenscript Bold.* FontShop "FontFont" series, The Netherlands, 1991
Design Just van Rossum

*Totally Gothic.* Emigre Graphics, USA, 1990
Design Zuzana Licko

abc

200 PT.        150 PT.        72 PT.        48 PT.        36 PT.        18 PT.

ABCDEFGHIK

LMNOPQRS

TUVWXYZ

abcdefghijklmnopqrstuvwxyz

*Spindly Bastard.* UK, 1990. Design Jonathan Barnbrook

Posters. Applications of Bastard. UK, 1990
Design Jonathan Barnbrook

THIS IS PROTOTYPE. EACH LETTER IS
UPPER AND LOWER CASE SERIF AND
SANS SERIF. THE LETTERFORMS ARE
CREATED BY COLLAGING PARTS FROM
ABOUT TEN OTHER TYPEFACES
INCLUDING GILL, PERPETUA, FUTURA AND
BEMBO. IT WAS IMPORTANT TO KEEP ALL
THE COMPONENTS THE SAME TO
EMPHASISE THAT IT WAS 'BROUGHT
TOGETHER' ON A COMPUTER RATHER
THAN HAND DRAWN

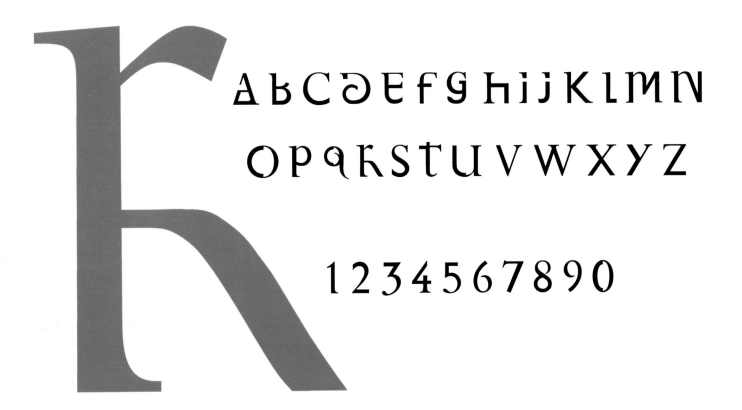

ABCDEFGHIJKLMN
OPQRSTUVWXYZ

1234567890

*Prototype.* UK, 1990. Design Jonathan Barnbrook

opposite: *Fudoni Bold Remix.* The Netherlands, 1991. Design Max Kisman

ABCDEFGH
abcdefgh
IJKLMNOPQ
ijklmnopq
RSTUVWXYZ
rstuvwxyz
1234567890

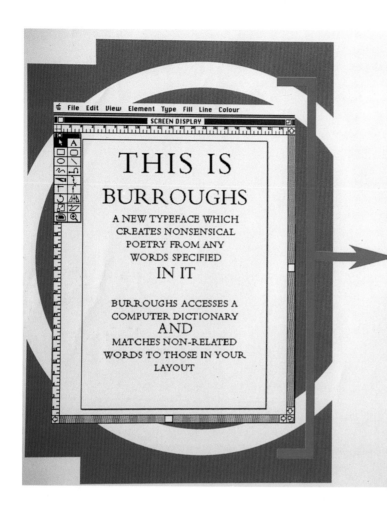

PRINTER OUTPUT

**LARD GUN**
CATHODE
REFER KNUCKLE IRATE
LINT ELSEWHERE
JOB BERLIN SCRAPE
FORTITUDE SMALL
CHINTZ HAM

CURVET INDICATOR HOME
OZONE LIMB
REMIND
KITSCH ELSEWHERE
INFORM IN CONTOUR FLASH
INVALID

above: *Burroughs.* UK, 1991. Design Jonathan Barnbrook
*Beowolf 23.* Random font. FontShop, The Netherlands, 1990. Design Erik van Blokland Just van Rossum

ABCDEFGH
abcdefgh
IJKLMNOPQ

i j k l m n o p q

RSTUVWXYZ
rstuvwxyz
1234567890

A B C D E F G H
a b c d e F g h
I J K L M N O P Q
M j k l m n o p q
R S T U V W X Y Z
r s t u v w x y z
1 2 3 4 5 6 7 8 9 0

opposite: *Boem Paukeslag Remix.* Poster
Application of Extended Maxm!x
*Typ/Typografisch Papier,* The Netherlands, 1991. Design Max Kisman

# BOEM

## PAUKESLAG

daar ligt alles        PLAT

O——————o

weer razen violen cello bassen koperen triangel

trommels PAUKEN

razen rennen razen rennen razen RENNEN

drama in volle slag hoeren slangen werpen zich op eerlike

mannen het gezin wankelt de FabrHek wankelt

de eer wankelt ligt er

alle begrippen VALLEN

HALT!

Repressed Victorian Roman

( A B C D E F G H I J K L M N O P Q R S T U V W X Y Z )

[ a b c d e f g h i j k l m n o p q r s t u v w x y z ]

(ABCDEFGHIJKLMNOPQRSTUVWXYZ) [ 1 2 3 4 5 6 7 8 9 0 ]

[abcdefghijklmnopqrstuvwxyz]

[1234567890]

JOHN RUSKIN

Although his theories regarding architecture and society have been widely read and accepted as the words of the modern movement, John Ruskin's bizarre fear of sexual activity haunted him for many years. These horrors, although shrouded in secrecy throughout his lifetime, and by his principal biographers, are confirmed in a series of letters and diary entries found, long after his death, under a floor-board in his study. After marrying Effie Gray, who was born in the room in which Ruskin's grandfather had committed suicide, he declared her "unfit for consumation", adding that he would reconsider when she reached the age of twenty-five (he was twenty-eight and she was nineteen). Six years later, on her twenty-fifth birthday, Ruskin had still not reckoned with his legendary disdain for pubic hair, and told her that she was still unfit, citing religious reasons for his abstention. Quite shortly after, the marriage was anulled, and Effie was remarried to the Pre-Raphaelite painter, John Millais.

above: *Repressed Victorian Roman.* USA, 1989

opposite top: *Canicopulus Script.* USA, 1989

opposite: *Barry Sans Serif.* USA, 1989   Design  Barry Deck

Caricopulus Script

(ABCDEFGHIJKLMNOPQRSTUVWXYZ
[abcdefghijklmnopqrstuvwxyz]
[1234567890]

(ABCDEFGHIJKLMNOPQRSTUVWXYZ)
[abcdefghijklmnopqrstuvwxyz]
[1234567890]

Eric Gill

There had been a string of infatuations put up with by his infinitely suffering wife Ethel Mary. Now we know the names. Here the biographer's task was simple enough: a trip to Los Angeles to read Gill's diaries in which he noted such occasions along with much mundane description (financial &?) and the focus of his personal life necessary for invoicing clergy and making van returns. But these affairs were not, except in a few cases, matters of the heart. The picture we are given is of a mildly pathological character; a vaguely priapish trying to keep jealousies calm as his extended family. There were incestuous episodes (sisters and daughters), experiments with prostitutes, even with a dog. Gill announced his difference immediately in his dress. His standard garment came to be a penis-freeing smock the rationale for which he advanced in several essays and pamphlets. And his attitude to women was quite consciously medieval. He wanted them simple and undecorated covered up in public and confined to domestic and agricultural activities. Despite himself, he did fall for the provocation offered by several modern or 'new' women of his acquaintance. As Mac-Carthy points out, the missionary trait ran in the Gill family: a grandfather and a brother served in the South Seas. For Eric 'missionary' could be understood in every sense of the word.
-Robin Kinross, Blueprint

---

BARRY SANS SERIF

( A B C D E F G H I J K L M N O P Q R S T U V W X Y Z )
[ a b c d e F g h i j k l m n o p q r s t u v w x y z ]
{ 1 2 3 4 5 6 7 8 9 0 }

(ABCDEFGHIJKLMNOPQRSTUVWXYZ)
[abcdeFghijklmnopqrstuvwxyz]
{1234567890}

The latest force to rear its ugly head on the ever-unfolding continuum of the postscript font design frontier, former disciple of the infamous vectorial school and recent amateur baron of autotrace typography, is Barry Deck. He cuts his punches in a frenzy of anal-retentive commands, producing a vulgar flow of vector based bezier curve coordinates which are infinitely reproducible. Fueled by almost two grueling years of damn-nearly continuous sexual frustration as a graduate student at California Institute of the Arts, he designs fonts which combine influences from the past with lewd references to the boundlessness of his own lust (as focused on fetishized typographical form), and the vital energy and singleminded internal and external drive necessary to blow these little characters right out of the laserwriter and into the future. Held in his hand for days at a time, the indispensable mouse becomes an extension of the phallus, and the outcome reproduces itself in endlessly reconfiguring orgies of language and dyslexic "FluFFemes" on the printed page. The typefaces produced under these conditions, with this methodology, exhibit the sort of spontaneity and passion that exists within sexuality itself. A combination of all Barry relishes in typography, Barry Sans Serif is one such face.

ABCDEFGHIJKLMN
OPQRSTUVWXYZ
abcdefghijklmnop
qrstuvwxyz
[1234567890]
№ @ ! % $ & ?

ABCDEFGHIJKLMN
OPQRSTUVWXYZ
abcdefghijklmnop
qrstuvwxyz
[1234567890]
№ at ! % $ ampers-AND & ?

*Template Gothic*. USA, 1990. Design Barry Deck

*Surfer*. Magazine pages. Application of Template Gothic and Industry Sans Serif
Surfer Publications, USA, 1991. Art director David Carson

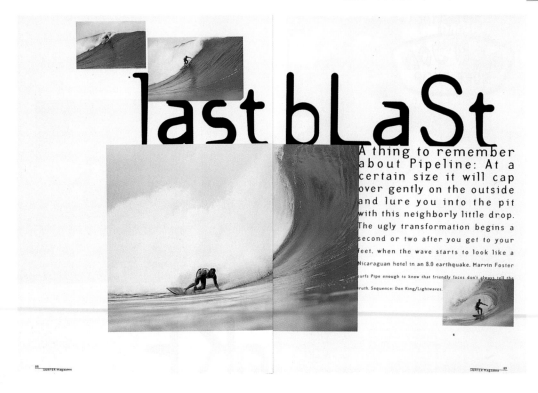

last bLaSt

A thing to remember
about Pipeline: At a
certain size it will cap
over gently on the outside
and lure you into the pit
with this neighborly little drop.
The ugly transformation begins a
second or two after you get to your
feet, when the wave starts to look like a
Nicaraguan hotel in an 8.0 earthquake. Marvin Foster
surfs Pipe enough to know that friendly faces don't always tell the
truth. Sequence: Don King/Lightwaves.

opposite:
*Industry Sans Serif Bold.* USA, 1991

*Circa 91.* Poster/flyer. Application of Industry
The Museum of Contemporary Art, USA, 1991
Design Barry Deck

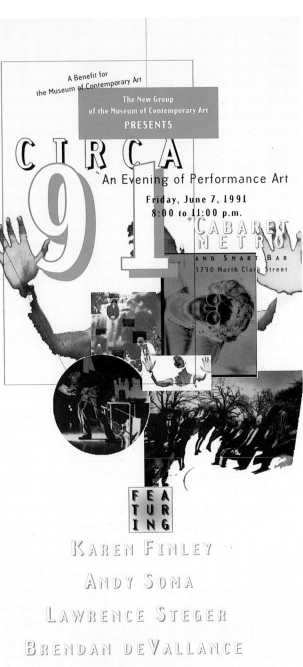

A Benefit for
the Museum of Contemporary Art

**The New Group
of the Museum of Contemporary Art
PRESENTS**

# CIRCA
## 91
An Evening of Performance Art
**Friday, June 7, 1991**
8:00 to 11:00 p.m.
@ CABARET
METRO
AND SMART BAR
3730 North Clark Street

FEATURING

KAREN FINLEY

ANDY SOMA

LAWRENCE STEGER

BRENDAN deVALLANCE

NANCY FOREST BROWN

IRIS MOORE

Live musical entertainment by
BIG HAT
AND
MAESTRO SUBGUM
AND THE WHOLE

1. Karen Finley
2. Brendan deVallance
3. Nancy Forest Brown
4. Big Hat
5. Maestro Subgum and the Whole

Hear recorded excerpts from "Works in Progress"
by Los Angeles radio performance artist
JOE FRANK

OPEN BAR UNTIL 11PM

Hours:
Gallery: Tuesday-Saturday 11:00-5:00, Sunday 12:00-5:00 Office: Monday-Friday 10:00-6:00

Y·O·U·R
N·A·M·E
H·E·R·E

LACE is supported in part by
Art Matters inc., Border Grill,
CITY, the California Arts Coun-
cil, Community Redevelopment
Agency of the City of Los Ange-
les, Cultural Affairs Depart-
ment of the City of Los Angeles,
the James Irvine Foundation,
S.K. Kojima and Co., L.A. Eyeworks,
Meet the Composer, MIKA Com-
pany, the National Endowment
for the Arts, Norton Family
Foundation, Proton Corporation,
Rockefeller Foundation,
Yamaha International, and the
FRIENDS and SUPPORTERS of LACE.

FilmForum continues its
programming in the LACE
Performance Space. For
further information call
[213] 276-7452.

free one-year membership to LACE.
hands-on experience in the process, and a
5650 to volunteer your time and receive
opment techniques. Please call 213 624-
tery and performance production and devel-
portunity to participate in all aspects of gal-
laboratory where volunteers are given the op-
involved in fundraising for LACE! LACE is a
face the challenges of development and get
putting together a visual arts exhibition!
stallation, and gain first-hand experience
performance, the ins and outs of media in-
learn the technical aspects of lighting for
LACE NEEDS VOLUNTEERS!

lay
n c
lin
nce
1fo

NonProfit
U. S. Postage
Paid
Permit #35671
Los Angeles, CA

september 89
213.624.5650
Los Angeles, CA 90021
1804 Industrial Street
Los Angeles Contemporary Exhibitions

STAFF
Anne Bray, Video Coordinator
Erica Bornstein, Performance Coordinator
Danae Falliers, Acting Development Coordinator
Laurie Garris, Acting Director
Jinger Heffner, Exhibitions Coordinator
Deborah King, Administrative Assistant
Jane Leslie, Bookkeeper    INTERNS/VOLUNTEERS
Dan Bernier, Bookstore Manager
June Scott, Development Assistant
Joy Silverman, Executive Director

Brian Baltin, Naomi Putterman/Performance Interns
Caroline Czirr/Video Intern
Alyssa Resnick/Exhibitions Intern
Sarah Vogwill/Bookstore Intern

MEMBERSHIP

MEMBER $30
Receives the LACE bi-monthly calendar with advance notice and invitations to all openings. 10% discount at the LACE Bookstore. Members-only discount to LACE performances, and with select Los Angeles merchants.

FAN $100
Receives all of the above PLUS one LACE publication.

FRIEND of LACE $250
Receives all of the above PLUS your name in lights on our illuminated, digital display, PLUS invitations to attend at least two exceptional events which highlight noteworthy people and ideas.

SUPPORTER $1000
Receives all the benefits of the FRIENDS, PLUS an invitation to attend a special Supporters-only Artists' event. PLUS your name on a permanent earthquake support plate on the LACE building. Your $1000 contribution literally "supports" LACE!

ARTIST/STUDENT/SENIOR MEMBER $20
Same benefits as Member.

Make checks payable to Los Angeles Contemporary Exhibitions or LACE

NAME: _____
ADDRESS: _____
CITY/STATE/ZIP: _____
PHONE: _____

SEND TO:
Los Angeles Contemporary Exhibitions
1804 Industrial Street
Los Angeles, CA 90021

Flyer. Application of Keedy
Los Angeles Contemporary Exhibitions, USA, 1989

opposite top: *Keedy Sans Bold.* USA, 1989

opposite: *Hard Times Regular.* USA, 1990
Design Jeffery Keedy

ABCDEFGH
abcdefgh
IJKLMNOPQ
ijklmnopq
RSTUVWXYZ
rstuvwxyz
1234567890

ABCDEFGH
abcdefgh
IJKLMNOPQ
ijklmnopq
RSTUVWXYZ
rstuvwxyz
1234567890

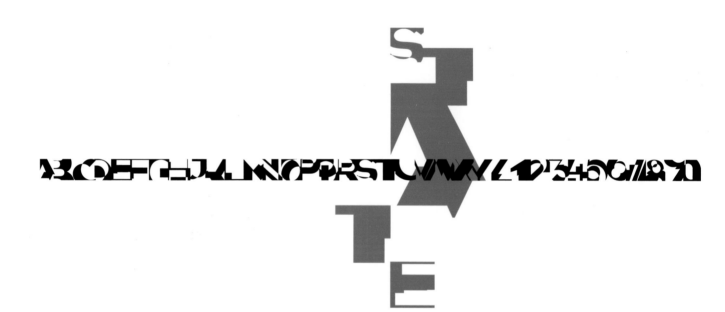

*F State.* UK, 1991

opposite: Application of F State. *State* poster. FontShop, UK, 1991. Design Neville Brody

FUSE ALINE THROUGH CHAOS OF COMMUNICATION

**index**

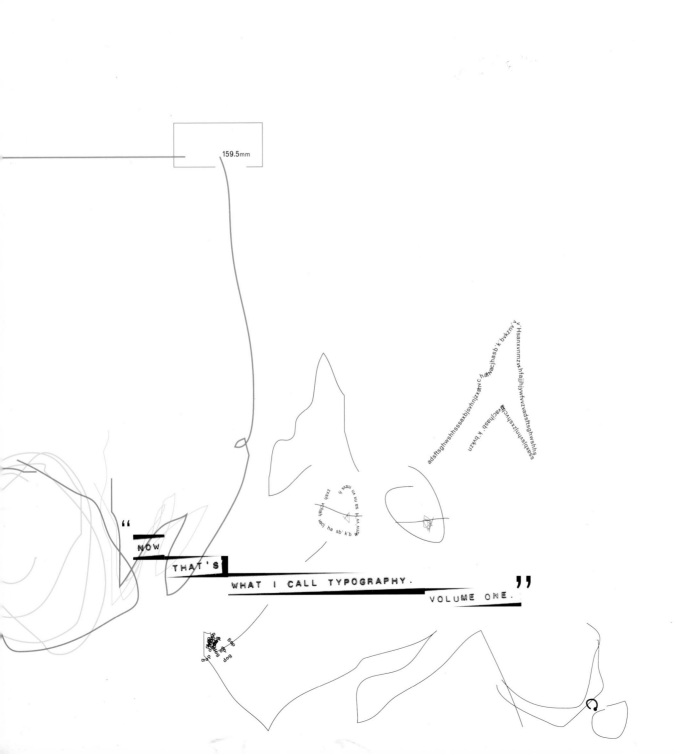

159.5mm

" NOW

THAT'S

WHAT I CALL TYPOGRAPHY.

VOLUME ONE. "